IMAGES
of *America*

EDDY COUNTY

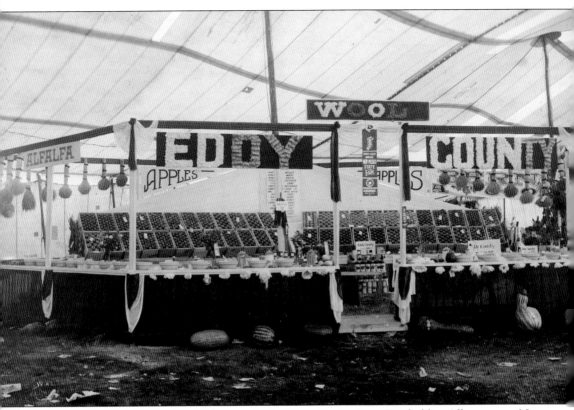

Featured is Eddy County's exhibit entry for the New Mexico State Fair held in Albuquerque, New Mexico, in 1916. As the Grand Royal Prize winner, Eddy County was awarded $1,000 and the Royal Purple Ribbon, which is seen hanging in the middle of the exhibit entrance.

ON THE COVER: Patriotism still ran high in 1949, four years after the end of World War II, as the Benevolent and Protective Order of Elks sponsored this rodeo theme parade. Proceeding south on Canyon Street in Carlsbad, local members of all branches of the military carry a huge flag that thrills crowds on a hot July afternoon.

IMAGES
of America

EDDY COUNTY

Donna Blake Birchell and
The Southeastern New Mexico Historical Society

ARCADIA
PUBLISHING

Published by Arcadia Publishing
Charleston, South Carolina

Printed in the United States of America

Library of Congress Control Number: 2010928311

For all general information, please contact Arcadia Publishing:
Telephone 843-853-2070
Fax 843-853-0044
E-mail sales@arcadiapublishing.com
For customer service and orders:
Toll-Free 1-888-313-2665

Visit us on the Internet at www.arcadiapublishing.com

*For all the citizens of Eddy County whose enduring pioneer spirit
forged a county like none other in the state of New Mexico*

CONTENTS

ACKNOWLEDGMENTS

This book is the result of countless hours of work that would not have been possible without the historical-preservation efforts of the Southeastern New Mexico Historical Society, namely Jed Howard. His willingness to collect and house the vast numbers of vintage photographs is second to none, and I thank him for his help and allowing me to pick his brain.

I could not go any further without thanking the instigator of all of this, my very good friend Samantha Villa. You do not know what this means to me.

To Betty Bass, a dear friend and relative to nearly everyone mentioned in *Eddy County*, I appreciate your insights into the family histories and the use of your precious family photographs.

For Jerry Birchell, whose sincere encouragement, pride, and understanding helped to keep me focused throughout the process, thank you for putting up with my panic attacks. You deserve a medal. I really appreciate and cherish you!

To Jared Jackson, editor extraordinaire, I extend a huge thank-you for taking a chance on me the second time and being so easy to work with—you're the best!

Many thanks to James Owens for the use of your photographs and being so dedicated to history. You are a true friend to me and the past.

Thank you to the members of the Southeastern New Mexico Historical Society for welcoming me into the group and being so supportive of both of our projects.

Once again, to Michael and Justin Birchell, two of the best sons a person could ever ask for, you both have made your father and me very proud of the men you have become. Love you always.

All images in this book are from the archives of the Southeastern New Mexico Historical Society, unless otherwise noted.

INTRODUCTION

One of 33 counties in New Mexico, Eddy County was named after Charles Bishop Eddy, who implemented one of the largest promotional schemes of his century to irrigate the arid land of Southeastern New Mexico. On January 25, 1889, Eddy County was carved out of the massive Lincoln County, which took up nearly all of the southeastern side of the state at that time. Eddy County soon drew attention to itself as an agricultural center in the West. The early years of Eddy County were tumultuous, with the hamlet of Seven Rivers being the largest settlement in the area. It was said that no one died of natural causes in Seven Rivers, and when the cemetery was relocated to Artesia to accommodate Brantley Lake State Park, the large amounts of lead bullets found in the graves proved this theory to be true.

By a vote of 331 for and 83 against, Eddy (soon to be Carlsbad) was elected the county seat over its sister town, Seven Rivers. This decision eventually leads to the fall of Seven Rivers in 1896, as all focus was drawn south to the burgeoning town of Eddy. Consisting of disgruntled small ranchers who felt they were being victimized by the larger ranches, the Seven Rivers Warriors clashed against the Lincoln County Regulators (whose ranks included Billy the Kid), thus beginning the Lincoln County War following the murder of John Tunstall in 1878 by one of the warrior members.

Farming and ranching played a huge role in the development of the Pecos River Valley, bringing in settlers from all over the world, but it was the 1913 discovery of black gold in Dayton, New Mexico, 8 miles south of Artesia, that gave the boost the county needed. The oil and gas industry is still a vital part of survival, especially in Artesia, the location of several large oil companies' headquarters. It was the drilling for this oil that lead to the discovery of one of the largest deposits of potash in the world, located just east of Carlsbad.

The oil industry gives back to the community in many ways, but one of the most noticeable is through the donations of beautiful, larger-than-life sculptures, which grace Artesia's downtown. *The Trail Boss* by Vic Payne, *The Vaquero* by Mike Hamby, and *The Rustler* and Artesia's first lady, *Sallie Chisum*, by Robert Summers are just the beginning of the History in Bronze series that was slated for the oil town.

Carlsbad, the largest city in Eddy County, is supported by many smaller towns, which have played a role in the region. They are Hope, Queen, Lakewood, Carlsbad Caverns, Loving, White's City, Malaga, Loco Hills, Lake McMillan, Atoka, Dayton, Harroun, Rocky Arroyo, Phenix, and Black River. The countryside is littered with remnants of ghost towns; small reminders of a life once lived, each with its own story.

Eddy County's history is rich and vast, fully deserving preservation for future generations to come. It boggles the mind as to the amount of history that has occurred in the county over the past century.

One

BIRTH OF A COUNTY

Long before Eddy County came into existence, it was a part of the largest county in the United States: Lincoln County, which spanned over 27,000 square miles, encompassing nearly a fourth of New Mexico. It was also one of the most dangerous, with documents showing over 9,000 fugitives who had migrated to the county to escape Texas law. In total, there was over $90,000 in rewards posted on them.

Eddy County was originally the entire Southeastern corner of New Mexico but was reduced to form Lea County in 1917. This first separation was the result of a petition to the Territorial Legislature by Charles B. Eddy, Joseph C. Lea, and Patrick F. Garrett, founders of both Eddy and Chaves Counties.

The resulting county was named, as well as the small town that sprang up, after Charles Bishop Eddy. Eddy was a New York cattleman who ventured west to partner with banker Amos Bissell in developing the Eddy-Bissell Cattle Company. Eddy also succeeded in catapulting the Pecos Valley into one of the most ambitious promotional schemes seen in that century.

During the establishment of surveying the county lines, a two-mile mistake to the east was made that put Badgerville, later renamed Hope, into another county—ultimately losing county commissioner office positions for a short time. The mistake was corrected, and Badgerville was returned to Eddy County.

The development of Eddy County stemmed from water. The Pecos River, which runs through the county, provided the valley with the means to grow crops and develop towns. To move these crops to market, James J. Hagerman, who knew how vital trains and the services they provided were to the survival of community, built a railroad.

Wiping out dams and irrigation canals to the point of needing the federal government to intervene, natural disasters threatened to collapse the economy of the town of Eddy. The U.S. Reclamation Service was authorized to take over the Carlsbad Irrigation Project, resulting in New Mexico having its first successful reclamation project in 1906, which is said to be one of the earliest projects in the nation.

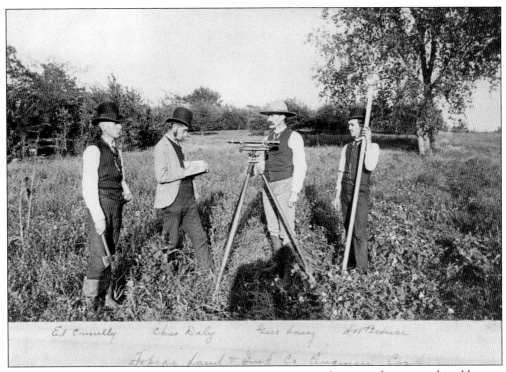

Ed Connelly Chas Daly Gus Lacy H.W. Brown

Topeka Land & Invst Co. Engineer Corps

A group of surveyors hired by the Pecos Valley Investment Company begin some of the first platting of Eddy, later to become the county seat of Eddy County. Territorial surveyors, moving down through the valley establishing section corners, first came to Seven Rivers in 1883.

Described as having piercing-blue eyes and jet-black hair, Charles Bishop Eddy, a native of Milford, New York, embraced the Pecos Valley, immediately seeing its potential. With the help of his brother J. A. Eddy, he ran his cattle operation close to where present-day Carlsbad is located. The ultimate salesperson, Eddy recruited a host of investors to bring his vision to fruition.

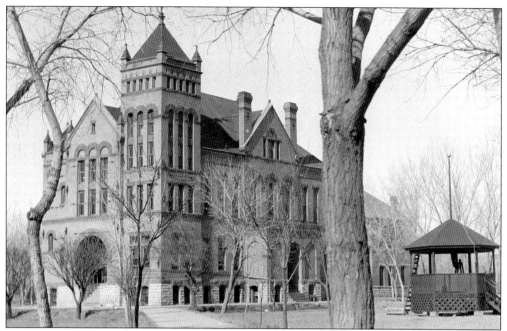

The original Eddy County Courthouse, completed in 1892 at the cost of $30,000, was done in a Gothic Victorian style and made of locally manufactured brick. Land, procured from C. B. Eddy at no cost to the county, was located on north Canal Street. Officials moved into the building on June 25, 1892. The courthouse had to be enlarged in 1914 at the cost of $170,000.

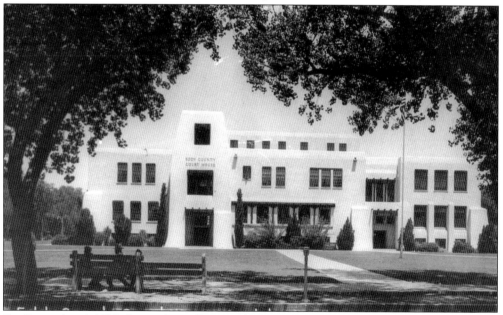

On September 6, 1938, the much smaller courthouse built by Lembke Construction Company of Albuquerque was to be replaced by one that was built in Pueblo Revival style. WPA workers were used to complete this task, and expenses totaled $189,000. Cattle brands of the regional ranchers were etched into the west doorframe in 1940, proving a unique feature. Architect R. W. Vorhees changed the plans from traditional to pueblo revival to reflect its southwest setting.

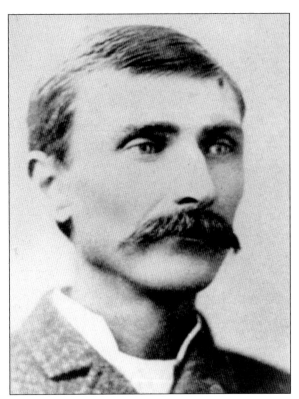

Patrick Garrett, a customs agent, gentleman sheriff, and cattleman, owned a brick livery stable in Carlsbad, then known as Eddy, on the corner of Fox and Canal Streets, where the First National Bank was to be built later in 1893. Garrett was asked to run for sheriff of Lincoln County by cattle baron, John Chisum, who wanted to rid the countryside of cattle rustlers, namely Billy the Kid. On July 14, 1881, Garrett accomplished that goal by ending Billy's career with a bullet.

James J. Hagerman, Colorado business man and mine owner, was brought to the Pecos Valley at the urging of Charles Eddy. Credited for being the major source of investment in the valley, an investment that nearly bankrupted him, Hagerman moved to South Springs, near Roswell. His son, Herbert, was briefly a governor of the Territory of New Mexico during Teddy Roosevelt's administration.

As a newspaper publisher from St. Louis, Charles Greene was hired by Charles Eddy to promote the accolades of the Pecos Valley. Once he visited the area, he became an investor himself by purchasing large amounts of acreage, including a large farm near Dexter, New Mexico. Greene has a street and a subdivision named after him in Carlsbad.

Robert Weems Tansill was consumed by the reorganization of the Pecos Valley Irrigation and Investment Company. James Hagerman reorganized the company into the Pecos Valley Improvement Company. It was Tansill's wife, Mary, who suggested that the town's name should be changed from Eddy to Carlsbad. She suggested this because of her husband's improvements from the water in Karlsbad, Czechoslovakia, which mirrored those in the spring water that was near the flume. Karlsbad means "Karl's cure."

After several devastating floods and a financial collapse, the irrigation project finally was stabilized with the building of a concrete flume in 1904. On November 28, 1905, Secretary of the Interior Ethan Allen Hitchcock approved the purchase of the troubled project, which soon became one of the largest acquisitions by the U.S. Reclamation Service.

Financed by James J. Hagerman, the Pecos Valley Railroad was used in a variety of manners, initially to shuttle potential investors to the territory and eventually to become a means to transport crops to market and bring in building supplies. With the railroad's completion, travel time to nearby towns was cut drastically.

Two

Towns of Eddy County

The town of Artesia has seen four name changes over its time span. Starting out as Blake Springs and then becoming Miller Siding, which was named for a railroad employee, it provided a stop for the newly built Pecos Valley Railroad, serving also as a post office and stage stop. Then the small town spent a small time as Stegman, named after the husband of Sallie Chisum Robert, niece of cattle baron John Simpson Chisum. After Sallie's divorce from Baldwin Stegman and the discovery of artesian water wells in the area, the town's name finally changed to Artesia and was laid out on January 15, 1903.

The town of Seven Rivers existed during the Lincoln County War, with many of the participants taking refuge there. Originally tagged Dogtown for the large prairie dog population in the area, old Seven Rivers had basically two structures, which housed a post office, store, saloon, and boardinghouse. The name is derived from the seven springs in the area, which would eventually empty into the Pecos River.

The farming community of Lakewood hoped to be named county seat since it was larger than Eddy; however, its post office was not established until 1904. To the south of Eddy were the towns of Phenix, Loving, Otis, Lookout, Black River, Harroun, Malaga, and eventually White's City, with Corral near the Red Bluff Reservoir by the Texas border.

Located west of Artesia, Hope, or Badgerville, was originally a large community. It soon saw many troubles as its water supply began to dwindle and its dreams of being included along the railroad were dashed by the sinking of the Titanic in 1912, as the funds sank with the ship. The town's name was highly disputed, and one version of how the town was named involves a coin being tossed in the air to be shot by the winner. Joe Richards and Elder Miller did the shooting, with Richards saying, "I hope you lose." Richards won, choosing the name Hope.

Other settlements include the following: Atoka, Dayton, El Paso Gap, Queen, Espuela, Loco Hills, Oriental, Globe, and Illinois Camp, which all contributed to the development of Eddy County.

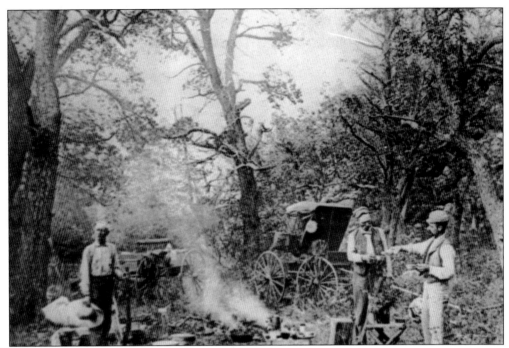

Although not technically a town, the Guadalupe Mountains harbored many settlements that were home to some of the most influential people involved in the development of Eddy County. Judges, lawmen, ranchers, and business owners were but a few who called the mountains home.

Hank Harrison Spring, shown in 1920 near White's City, is now called Rattlesnake Springs and is owned by the National Park Service. Rattlesnake Springs is the water source for the Carlsbad Caverns National Park and Washington Ranch. Provided by 20 springs, over 3 million gallons of water flow each day.

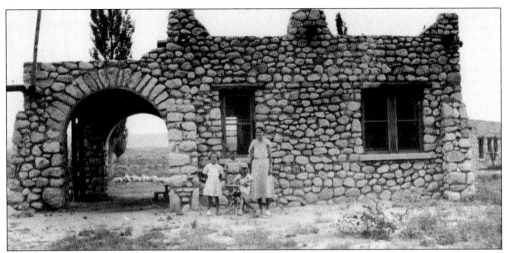

Here is one of Bill Washington's rock cabins at Washington Ranch, south of White's City. The El Paso Highway ran through the ranch at that time. This was called Washington's wild "tourist court proposition," which eventually lead to his downfall because the new highway bypassed his place by several miles. His dreams of a resort went unrealized.

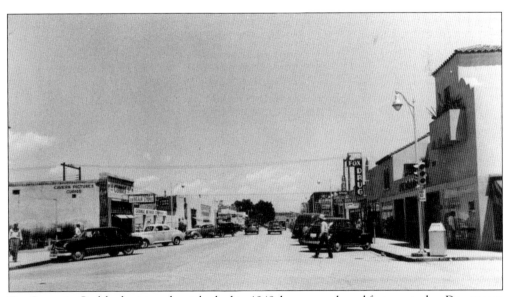

Fox Street in Carlsbad, pictured as it looked in 1949, has many shared features today. Downtown Carlsbad has some of the first streets in town to be paved. People were drawn to town by a variety of businesses such as Woolworth's, Wacker's, Anthony's, Star Pharmacy, and Collin Gerrells Menswear.

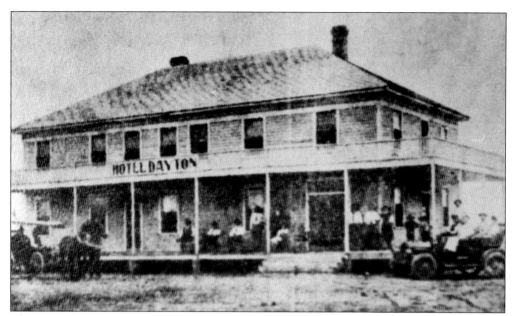

The town of Dayton was named for J. C. Day, who founded the town in 1902 on the northeast banks of the Penasco River, approximately 8 miles south of Artesia. During the winter of 1904, the entire town was moved to the west of the railroad that is with the exception of the post office and store, which belonged to Captain Chase.

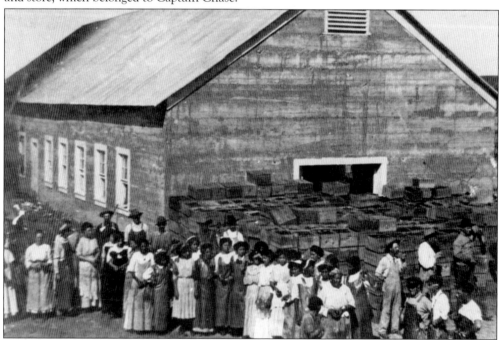

The work crew stands in front of the Lakewood Canning Factory on October 3, 1911. Virtually every woman in Lakewood and the surrounding towns worked in the factory, making $6 a day. The building, which cost $4,500 to build, was not large by today's standards, but the women were still able to produce 27,000 cans of tomatoes a day. During canning season, a crew totaled 85 people.

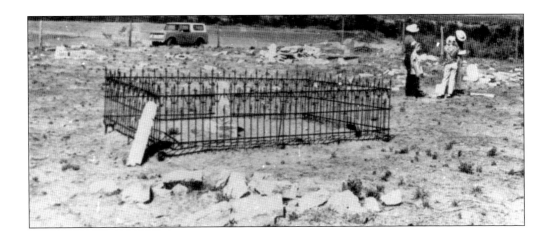

All that remains of Seven Rivers today is its cemetery. Due to the community being such a dangerous place to live, it was said that one could read a newspaper at night by gunfire. Ranchers, farmers, children, and outlaws were laid to rest together on the banks of the Pecos River. When Brantley Dam was built in 1988, it would cover a 4,000-square-foot area, possibly submerging the cemetery. The State had the cemetery moved to the Twin Oaks cemetery, north of Artesia. The photograph below shows how the cemetery looks today. (Above, courtesy of SENMHS; below, courtesy of James Owens.)

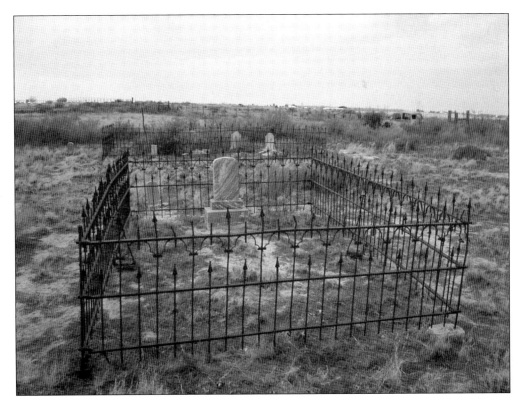

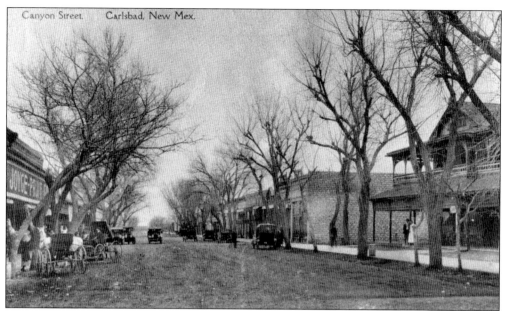

Charles B. Eddy, founder of Eddy (Carlsbad), was determined to beautify his town, which at first was stark and unappealing, by planting more than 6,000 trees along all the streets. Some of the trees came from the Roswell area and some from Toyah, Texas. The trees, mostly cottonwoods, were highly protected and prized.

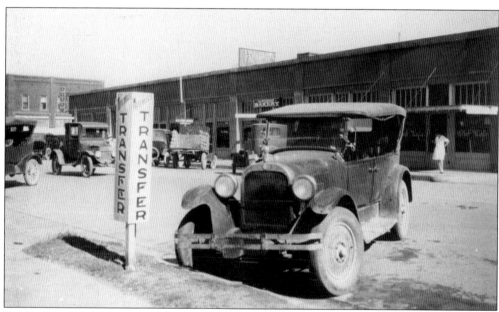

The Railway Mail Service and the Postal Transportation Service clerks used the Transfer Office in downtown Carlsbad. Their primary function was to "space" the amount of mail a rail car could carry, protect the mail during transfers between trains, and supervise the loading and unloading of the mail.

Downtown Carlsbad in 1948 was a bustling place. After World War II ended, the Carlsbad Army Airfield closed, but the men returned home to their families and started their lives over again. The potash mines employed many people in the county, and since Germany was the only competition, the need for mine workers rose tremendously, allowing the town to grow.

As Carlsbad's population grew, a one-lane bridge was built to allow automobiles to cross the river without relying on a ferry. A four-lane version was built in the 1940s, permitting traffic to run more efficiently to the growing suburb of La Huerta, which was to the north of Carlsbad.

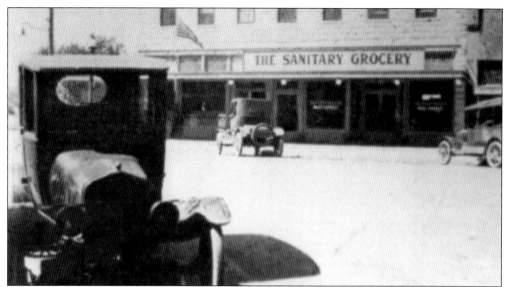

Sanitary Grocery of Artesia, shown in this 1927 image, was built of concrete blocks to look like artificial stone in 1905. Originally, the building housed a hotel and tavern and has been many businesses over the years. Currently, it is home to the Wellhead Restaurant and Brewpub and is on the National Register of Historic Places as of 1990.

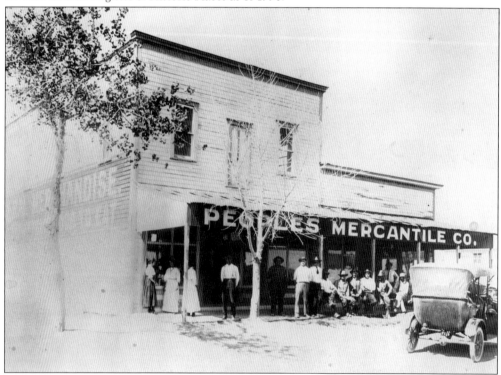

This image shows the People's Mercantile Company in Lakewood in 1920. Lakewood boasted a hardware store, bank, feed store, tomato cannery, a two-story brick schoolhouse, and a post office. Many of the families who originally settled Seven Rivers moved further north to Lakewood after Seven Rivers faded away.

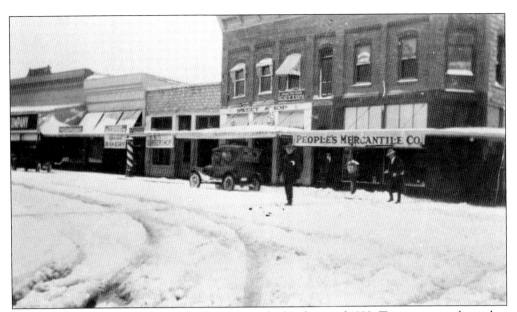

Shown is downtown Artesia as it looked during the big freeze of 1932. Temperatures plunged to 30 degrees below zero, beginning the series of devastating blizzards that destroyed the fruit trees of the Pecos Valley, forcing many farmers to turn to new crops.

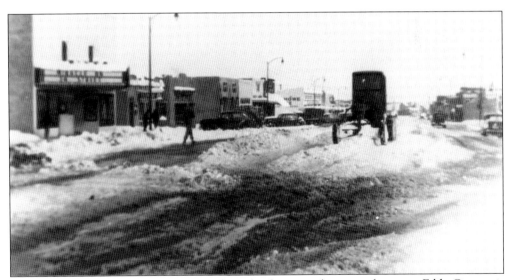

Significant snowfall in Artesia in 1948 brought the snowplow out of storage. Eddy County is known for its mild winters, and a snowfall of this size was sure to cause havoc in the streets of Artesia. This photograph represents at least a 1- to 3-inch snowfall.

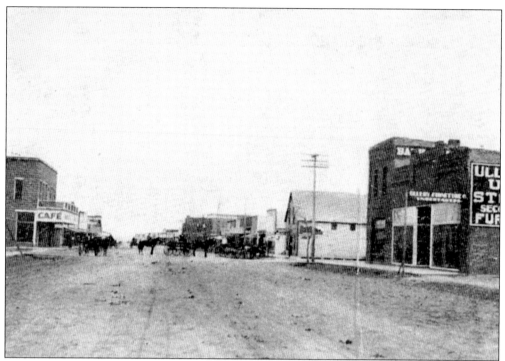

Pictured in 1907, Artesia, which had just been established in 1903, is already a thriving community. The name Artesia was suggested by John Richey to represent the newly discovered artesian wells. These wells aided the farming and ranching that dominated the area until 1923, which was when oil was discovered in the area. (Courtesy of the Historical Society of Southern New Mexico, #2993.)

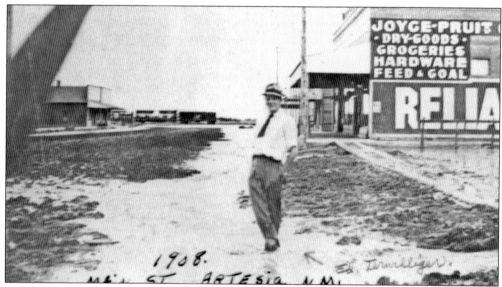

Ed Terwiliger of Artesia is shown standing in the remnants of a 1908 hailstorm, which littered the dirt street. There have been many stories of hailstorms so violent that the cowboys on the range had to remove the saddles from their horses and use them for shelter against the hailstones that could reach the size of a baseball. (Courtesy of HSSNM, #4912.)

CEMENT MILL

Globe was a settlement approximately 12 miles north of Carlsbad, located on the Atkinson Topeka and Santa Fe railway tracks. A tiny hamlet grew up around the Globe Mills and Mining Company, which mined gypsum and made it into plasterboard. All that remains of this town are cattle pens, since the mill burned down shortly after these photographs were taken in 1920.

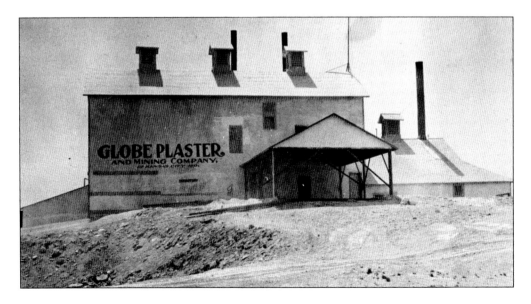

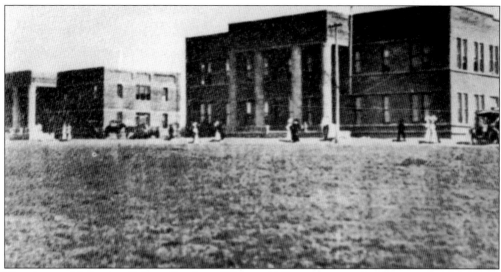

The Artesia Methodist College South, or Western College as it was also known, was one of five educational institutions that have been in Artesia. Being the most impressive of all the others, Western was a 20-acre campus with two buildings—the main college building and a dormitory. It opened its doors in the year 1909. Water for the school was provided by an artesian well that was 1,172 feet deep.

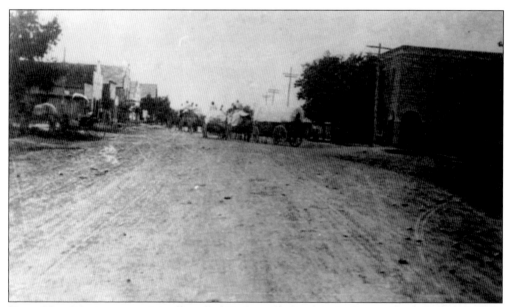

Hope, New Mexico, was originally called Badgerville because its first residents had to literally dig shelters for themselves into Penasco River bank. The building on the right with the arched doorway was the original Hope Bank, which still stands today. That cannot be said for the buildings on the left.

26

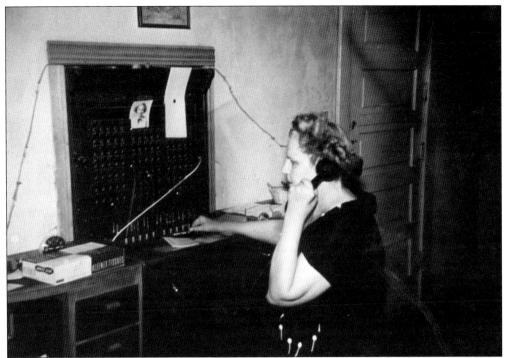

Bonnie Dittman, a telephone switchboard operator in Hope, is shown in this 1949 photograph. The Artesia Telephone Company established a system of 150 phones in Eddy County. Long distance was provided to Roswell, Carlsbad, and Hope. The company franchised in 1915 and charged rates of $2 for individual phone service and $3 for business lines.

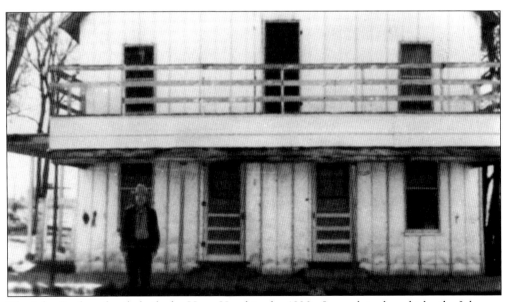

The John Beckett family built the Hope Hotel in the 1890s. It was later bought by the Johnson family in 1921 and then by the Altman family in 1950. The residents of Hope and hotel guests were served homemade meals. While the water held out, Hope was a booming community.

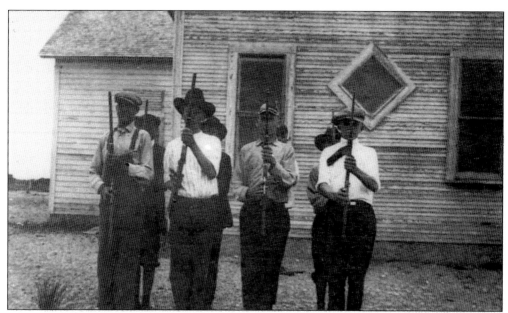

The Hope boys' drill team displayed their rifles in 1915, which was one year after the start of World War I. War raged in Europe and the *Lusitania* was recently sunk by a German U-Boat, so local boys and men were readying themselves for the war effort.

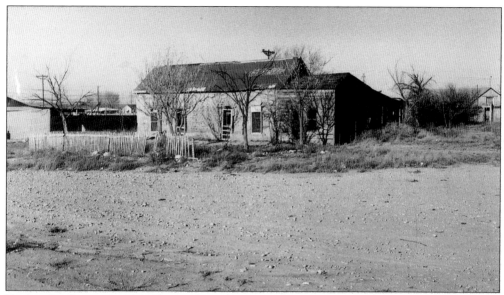

During the three years that Phenix existed, it earned a reputation for being one of the wildest towns of the west. Because of a ban on the sale of alcohol in Eddy 2 miles to the north, Phenix grew out of necessity. This image is the last building left standing from that era, which was torn down in 1989. The building was thought to have been a brothel.

Knowles, New Mexico, was a part of Eddy County for a short time due to a wrong survey. Once corrected, it became a part of Lea County. It was originally called Oasis because it was said to be the first settlement that one reached when traveling west from Texas.

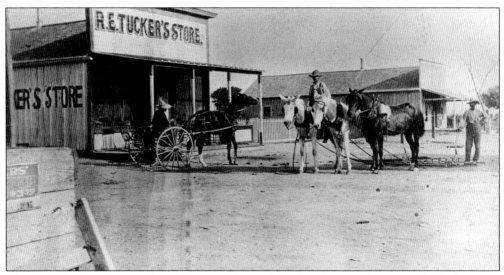

Charles P. Pardue, the president of Loving National Bank, rides in a dogcart pulled by his racer in front of Robert E. Tucker's store at the northwest corner of Loving at the intersection of Cedar and Third Streets in 1910. Tucker was the first postmaster of Loving.

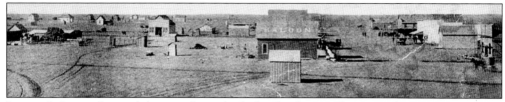

It is said the residents of Artesia always built for the future. Shown in this January 1, 1904, photograph, the barren landscape of the first town site was apparent, but it was soon to become a highly productive community. Artesia's first postmaster was Sallie Chisum Stegman; she recorded a whopping $4.36 in stamp sales for the first 40 days of operation. (Courtesy of HSSNM #2868.)

As with any community in the West, water was vital to the development and sustainability of a town. By 1914, Artesia was known as the Home of Abundance because of its crop production, which included alfalfa, cantaloupes, tomatoes, corn, onions, and sweet potatoes. Pecans are quickly becoming a large cash crop in the county.

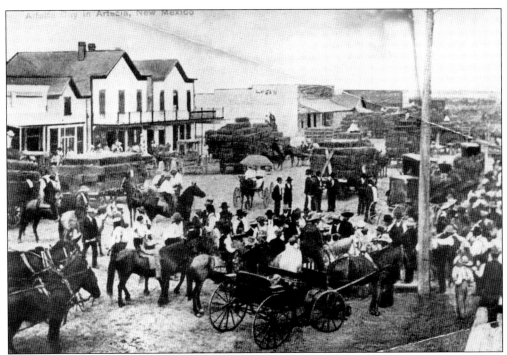

There is no doubt that the largest event in the early days of Eddy County was Alfalfa Day in Artesia. To celebrate having the finest electrically powered alfalfa meal mill in the Southwest, the citizens of Artesia would hold contests that included seeing which span of horses could pull the largest load of alfalfa hay. (Courtesy of HSSNM #4917.)

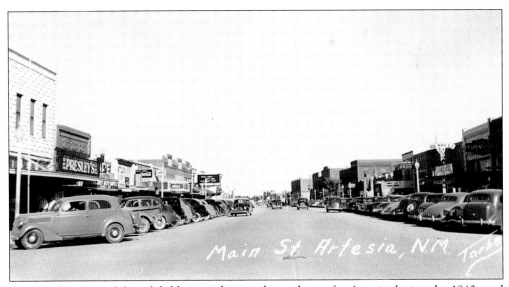

The development of the oil fields caused a population boom for Artesia during the 1940s and 1950s. The town had grown to a population of nearly 8,500 citizens by 1950. A Civil Aviation Authority airport, which was reportedly built for just under a million dollars, served as a training facility for pilots stationed at the nearby Roswell Army Air Field. (Courtesy of HSSNM#5656.)

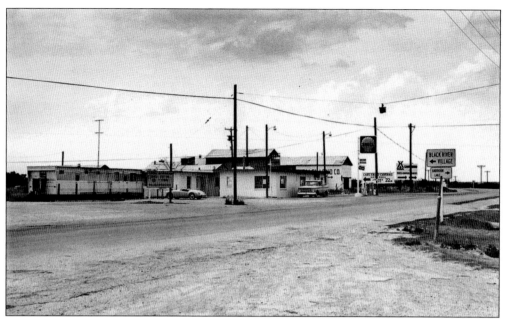

Named for the sweet Spanish wine made from a variety of grapes grown by Italian immigrants in the region, Malaga was originally known as Kirkwell until 1892. As a stop on the Pecos Valley Railroad, the community was able to get their crops to other parts of the state with ease. Although the vineyards are now nonexistent, the tiny community still remains. (Courtesy of HSSNM #4914.)

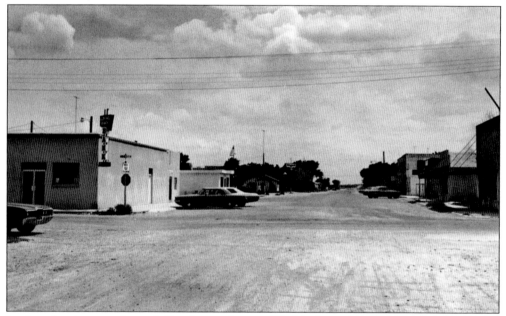

Loving, the tiny town located 10 miles southeast of Carlsbad, was known by many other names during its history. Originally called Vaud by its first Swiss residents, it would be changed to Florence in 1904 under the influence of the Italians who settled the area. The final name change in 1908 was to honor cattleman Oliver Loving, who was mortally wounded nearby. (Courtesy of HSSNM #4916.)

Three

THE GUADALUPE
MOUNTAINS

The Guadalupe Mountains have been described as "the southernmost extension of the Rocky Mountain range, lying within the State of New Mexico." Anyone who has hiked the many paths or just driven the winding roads knows this to be a ruggedly wild area. In a 1907 proclamation by Pres. Theodore Roosevelt, the Forest Service became involved to develop the Lincoln National Forest.

The early settlers of the Guadalupe's were of sturdy pioneer stock; the earliest of these was the Shattuck family who settled in 1885, accompanied by the Lyons family. Then came the Bass, Queen, Thayer, Kilgore, McCollaum, Ussery, Ares, Gage, Montgomery, Magby, Acrey, McGonagill, Howell, Larrimore, Lucas, Thomas, Plowman, Hughes, Crenshaw, Burleson, Smith, Williams, Rayroux, Kincaid, Shafer, Middleton, Ward, Pendleton, Lewis, Downs, and DeMoss families to settle in the rough mountainous area. In the limited space allotted here, it would be impossible to mention all of the accomplishments of these families.

The mountain range spans the three counties of Chaves, Otero, and Eddy and extends into Texas and resulting in El Capitan, which is at an elevation of 8,749 feet, making it the tallest point in Texas. Many cultures from Ancient Man, Native American, the Spaniards, and the white settlers have found the Guadalupes to be a beautiful, yet challenging, region in which to find shelter. The scarcity of water and the pure ruggedness turned many would-be homesteaders away, but the hearty few who did accept the challenge thrived.

Sheep, goats, and cattle herds were the main industries of local ranches, drawing the interests of not only did the Mescalero Apaches, who call the mountains home in rancherias, but also cattle rustlers, who seized the opportunity to snag a few head for their own. There are many accounts of entire herds being taken from the Black River area, south of Carlsbad to McKittrick Canyon, some 50 miles away. Conflicts between the settlers and the native tribes were commonplace, making the mountains a treacherous place in which to live.

Sitting Bull Falls Recreation Area is the playground of the Guadalupe Mountains. Located between Carlsbad and Queen, it possibly got its name from a tall tale involving Bill Jones whose nickname was Sitting Bull. Most people agree it was not named after Chief Sitting Bull, who was never in the area.

Members of the DeMoss family, longtime ranchers, fresh from a successful hunting trip in the foothills of the Guadalupe Mountains, proudly show off their prize. Shown from left to right are Jim DeMoss, Bertha Lewis, and Lena DeMoss. Water for the DeMoss ranch was provided by a seep spring inside a prospector's tunnel.

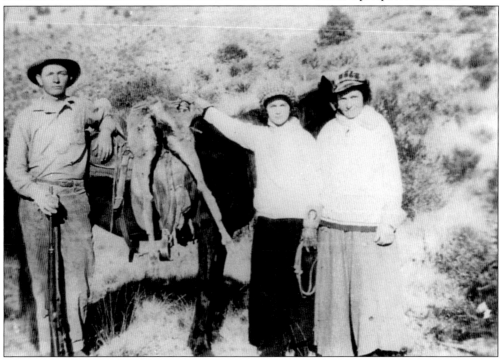

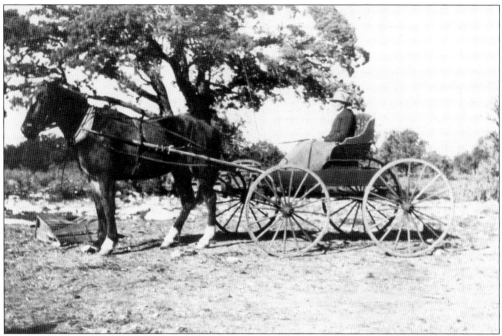

Martha Jane Boren Queen, shown in her wagon, was said to be a self-reliant woman, as was the case with many of the ranch wives who hauled water, planted and harvested crops, and tended livestock. She and her five children first lived in a 12-by-12-foot, dirt-floored, log cabin.

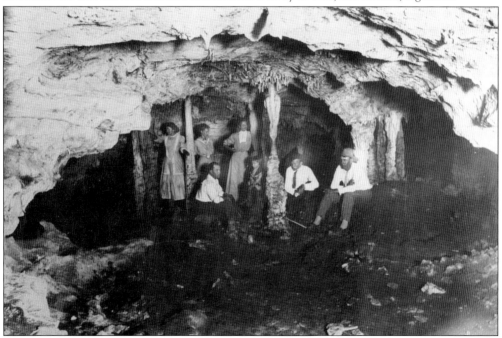

The hobby of exploring local caves was a great pastime in the late 1800s, as there were many caves dotting the limestone landscape. The citizens of the county seized the opportunity to explore the easily accessed openings to hold a Sunday picnic. McKittrick Cave, shown here, was also home to the hermit and stone mason Bob Brookshire for several years.

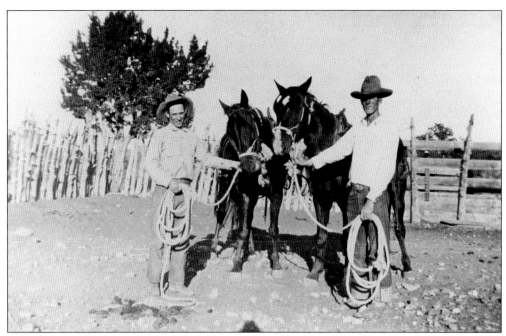

Vic Queen Jr. is pictured on the left in this 1921 image. He is standing with fellow rancher George DeMoss in a corral on Queen's ranch. Controversy followed the original Vic Queen once he befriended outlaw couple Martin and Beulah M'Rose, and John Wesley Hardin, all of whom spent time in the raucous town of Phenix.

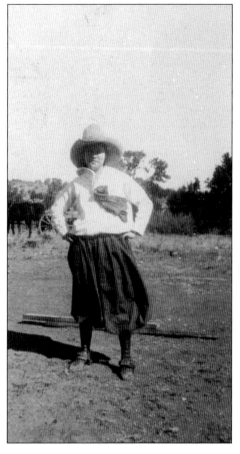

Hardly five-foot tall, no-nonsense Virginia Mae Taylor served as the first schoolteacher for the mountain community of Queen. Her gauchos and boots were of the utmost style in the 1920s, not to mention being very practical for the mountain way of life.

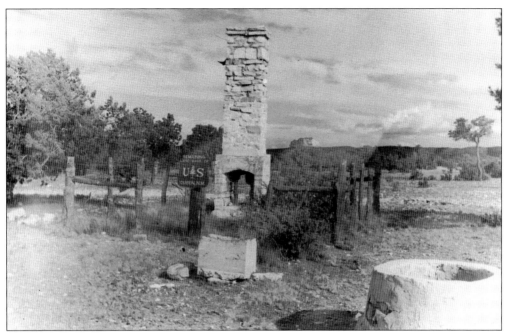

Here is the last remaining structure left standing in Queen, New Mexico. The chimney was the only part to survive a devastating fire, which destroyed the rest of the store building to which it was attached. Elias Gilkon Queen and family settled in the mountain in 1890 and donated the water for a store under the condition that the town would be named Queen.

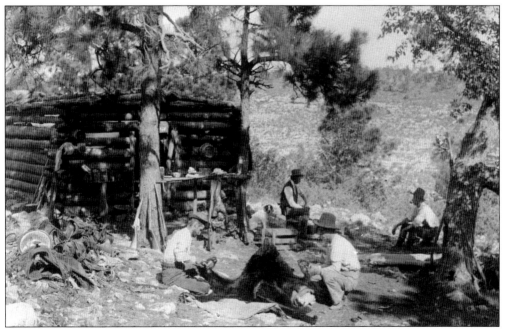

Guadalupe Mountain ranchers skin a brown bear in front of a typical line shack or hunter's cabin, which was built from timber found in the vast forest surrounding the Devil's Den area in 1932. Bears, mountain lions (sometimes referred to as panthers), and bobcats roamed freely in the mountains, causing havoc on livestock.

Taken by early photographer Ray V. Davis, this photograph features Carl Livingston, who was a renowned writer, speaker, banker, and historian. Livingston had a healthy rivalry with amateur archaeologist and museum curator, Bill Burnett. This rivalry reportedly divided the town of Carlsbad, with citizens choosing respective sides.

Some members of the founding families of the Guadalupe Mountains are represented in this 1927 photograph. From left to right, they include Opal Clark, Bernice Smith, Wallace Smith, Walter Thayer, Sam Jones, Oliver Shattuck, Cecil Cass, Gary Smith, Warren Smith, and Will Truitt.

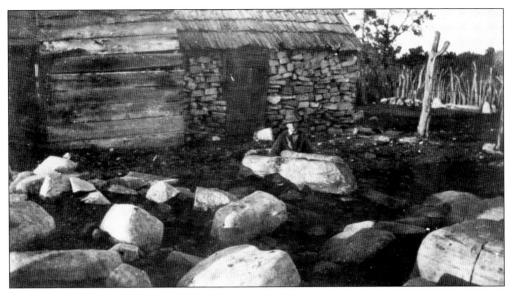

Backyard boulders instead of grass illustrate the pure ruggedness of the region. The Queen homestead, shown in this photograph, was built using timber and flagstone materials found in the mountainous area.

El Paso Gap teacher Mirram McMinn shows off her equestrian skills in 1920. She is sporting the same gauchos and boots worn by Queen teacher Virginia Taylor. One has to wonder what the fascination was at the time to stand on a horse's back since it seemed to be a popular pose.

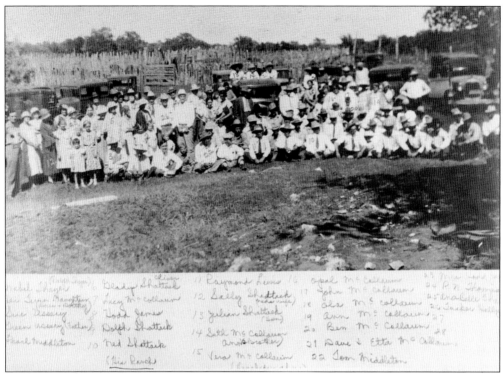

Mabel Shaugh Oday Shattuck 11 Raymond Lewis 16 Opal McCollaum 23 Wm Hill
 Lucy McCollaum 12 Sally Shattuck 17 John McCollaum 24 P.J. Thompson
 Todd Jones 13 Julian Shattuck 18 Les McCollaum 25 Sinkers Hill
 Dolph Shattuck 14 Seth McCollaum 19 Ann McCollaum
Frank Middleton 10 Ned Shattuck (and brothers) 20 Ben McCollaum 28
 (His Ranch) 15 Vera McCollaum 21 Dave & Etta McCollaum
 22 Tom Middleton

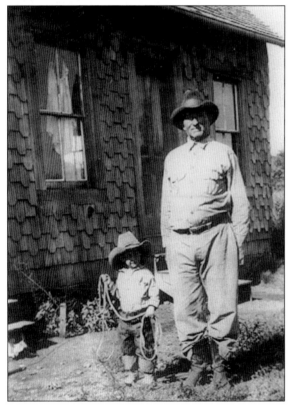

Nearly every ranch family of the Guadalupe Mountains is represented in this image of a barbeque picnic being held at Ned Shattuck's ranch house on Robinson's Draw. This photograph includes members of the Shattuck, Lewis, Jones, McCollaum, and Ussery families.

Edwin Summerfield (Ned) Shattuck and his grandson Floyd Hill are featured in this 1931 photograph. The Shattuck family came to New Mexico from Brown County, Texas, to settle in the "disreputable mountains," which were called this since no one wanted to venture into them. Ned's father, Captain Shattuck, was the first Eddy County School superintendent.

James Tulk, founder of Queen, is shown in the town of Lovington, New Mexico. Tulk was the postmaster and original storekeeper in Queen, New Mexico. He was described as a traveling merchant who preferred to sell his own stock but was not opposed to working in other stores.

Located across the street from the Middleton store, which housed the Queen chimney, the Tulk store was built in 1904. The Tulk sons (William, John, and Fleming) would go to Carlsbad for supplies, while the four daughters (Abbie, Elizabeth, Nettie, and Rhoda) worked the store and post office. The store was built with lumber obtained from Weed, a small town in the nearby Sacramento Mountains.

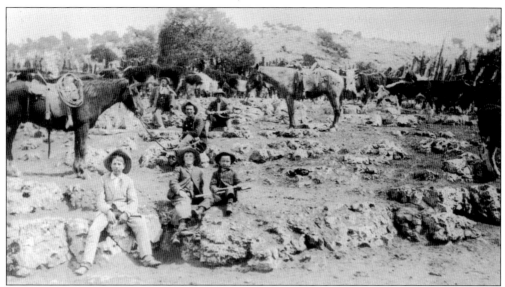

Bullis Springs is the setting for this 1910 photograph, featuring members of the Prude family at the ranch work pens. The known family members, pictured from back to front, are Claiborne, Lit, John, Thomas, and Johnny. John Prude would eventually sell Bullis Springs Ranch to his son-in-law, Carl Lewis.

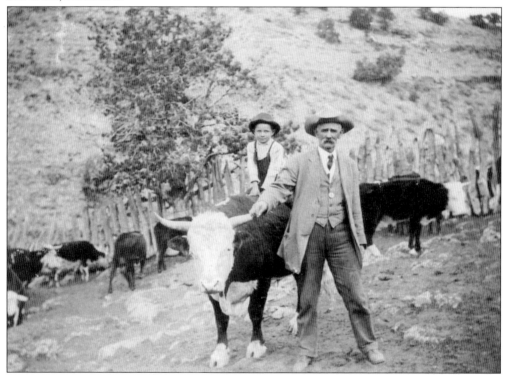

A Hereford bull furnishes small Johnny Prude a sturdy seat, while his grandfather, Claiborne Prude, provides a steadying hand on the bull's horn. This photograph was taken on the Prude Ranch in Bullis Springs, sometimes referred to as Shakehand Spring. (Courtesy of the Artesia Historical Museum and Art Center Collection.)

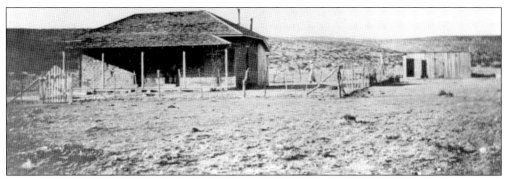

Shown is the Charles Adam Ward's first ranch in Little McKittrick in 1915. The brand for the Ward ranch was W-A. Tragedy struck the Ward family, when Charles's grandson Floyd was killed on a Japanese Prison Ship in the China Sea during World War II.

Known as Granny Queen, Jane Bolen Queen is pictured standing in the doorway of her mountain home in 1909. Although raising her family in poverty by Carlsbad standards, her children's occupations included mining engineer, artist, poet, musician, rancher, farmer, and businessman.

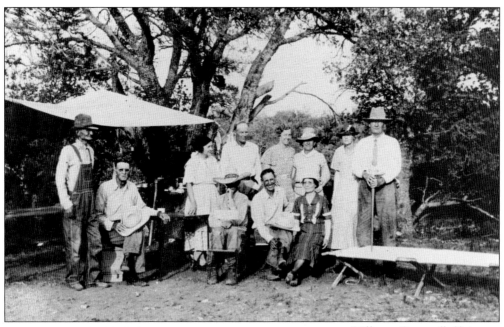

Hillman Queen (left) is pictured with family and friends at their place in the Guadalupe Mountains. When refrigerators came to the mountains, in order to defrost, Hillman was told to cut a small hole in the ice and put in boiling water to melt the ice. When Hillman used a hatchet to cut this hole and inadvertently cut the coolant line, a repairman had to explain why it could not be repaired.

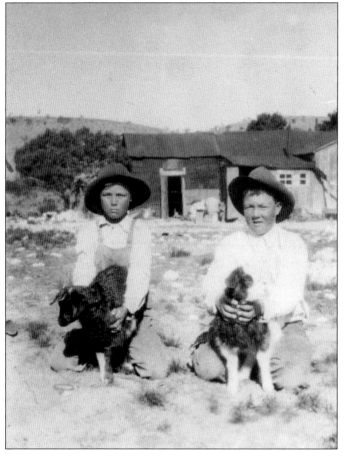

Douglas Magby (right) and his brother Darrell show off their prized goat and rooster. They are the sons of Jesse and Bessie Magby. It was said that the boys loved fried chicken, so not many chickens survived their hearty, growing-boys' appetites.

The members of the Burleson pioneer family pose for this 1925 image, which shows, from left to right, Alice Burleson, her son J. D. (John David), and her husband, Edward. Being friends with Billy the Kid, Edward had on occasion some time to pass with the outlaw in Fort Sumner and then again in the cave behind Sitting Bull Falls after being chased there by Native Americans.

John Green Ussery was one of a small number of ranchers in the area who raised horses instead of cattle. The Ussery ranch was near the mouth of Big Canyon. When Green's herd passed the Dudley homestead in Texas, Mary Dudley caught his eye with her horsemanship. He knew immediately that they would marry. From left to right are Green, his grandson Huling Jr., and his son Huling Sr.

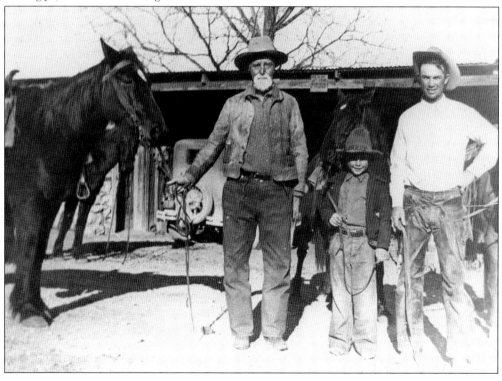

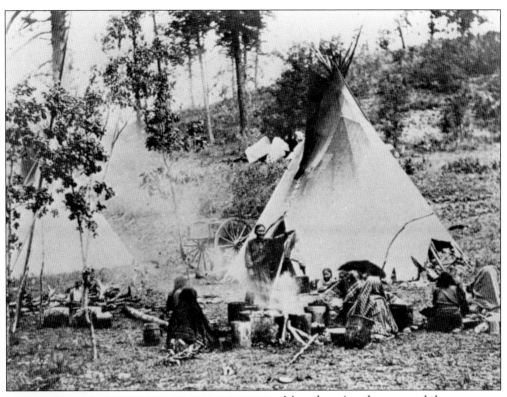

Mescalero Apaches roamed the Guadalupe Mountains for years before white settlers established their ranches. The Apache camps are called rancherias. Originally, they had settled in the Southern plains of Texas and were displaced by the Comanche between 1700 and 1750. Their particular band is called the Nit'ahende, "People who live against the mountains."

Mike Irbaine, a bachelor from Bakersfield, California, shown in this 1932 photograph, was a leading Basque sheep man of the Guadalupes. The Western United States was highly impacted by the sheep. Irbaine ran 10,000 head of sheep in the Guadalupe Mountains from Dog Canyon to his ranch in Last Chance Canyon.

Four

FEEDING THE COUNTY

The reason Eddy County exists today is solely because of the farmers and ranchers who settled in the Pecos River Valley along the river that provided the much-needed water to sustain land. Thanks to the efforts of Charles Eddy, Patrick Garrett, Robert Tansill, and John J. Hagerman, the largest irrigation project was born.

Turbulence shadowed the Carlsbad Irrigation Project, ranging from several devastating floods, which destroyed the wooden flume and floodgate systems to monetary failures that sent the project into receivership. Through the intervention of the U.S. government in 1904, irrigation has been regularly provided to county farmers and ranchers. Carlsbad would first get its drinking water from the Old Standpipe well, which has since been abandoned.

Carlsbad shipped nearly 500 head of cattle a week to the markets of Kansas City and Fort Worth. The first "Big Die" occurred in 1884 due to overstocking, killing many cattle in the county. The second would be in the early 1930s, during the Great Depression and Dust Bowl years.

Alfalfa was the first crop to yield a return, closely followed by cotton, in the county. Both are still large cash crops for the region, with pecans seeing a large resurgence. In recent years, many pecan orchards have been planted all around Eddy County, bringing in millions of dollars of profit for their producers.

There are reports of a massive herd of buffalo, which roamed the southeastern corner of New Mexico, providing food, shelter, and clothing to the native tribes. Over the years, these herds were greatly reduced by the buffalo hunters, and now only the telltale buffalo wallows are the only evidence the beasts were here. Large cattle barons, like Charles Goodnight and John Simpson Chisum, took over this land with their herds and turned Eddy County into one of the largest cattle producers in the state.

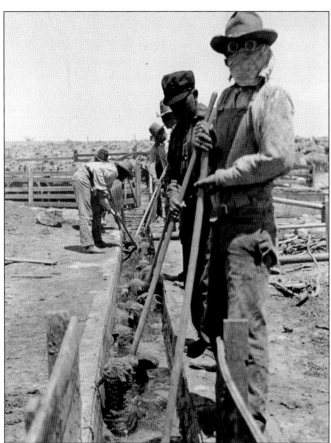

Sheep dipping rid the animals of parasites, allowing them to grow better wool. Parasite-free ewes produced more milk, therefore, producing stronger, rapidly growing lambs. Sheep were generally dipped twice a year in June and September or October.

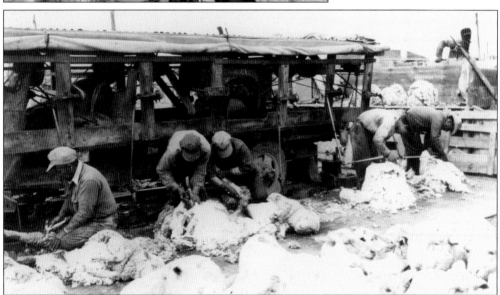

The hardworking crews of John Methola are shown sheep shearing in 1949 on the Cawley Ranch, using a Rand Motorized unit. The sheep-shearing machine was first introduced in 1888 and was driven by either steam or a combustible engine, saving the shearer both time and second cuts.

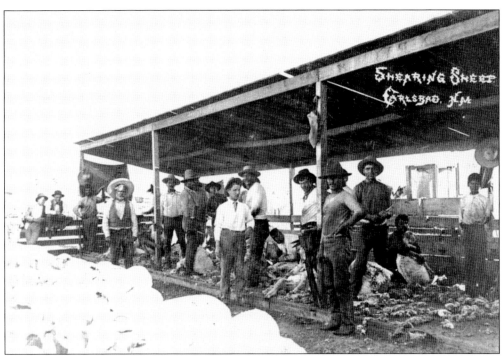

Sheep played a large part of the development of ranching in the Guadalupe foothills. Along with the raising of Angora goats, both of these animals provided the many ranches in the county with livelihoods to support their large families.

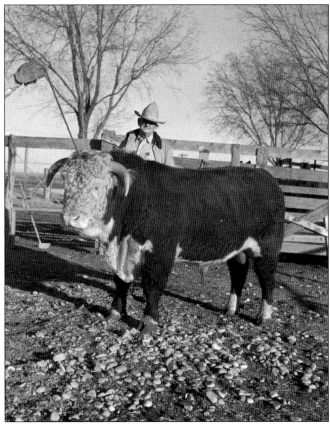

A photograph of Ned Shattuck's prized Hereford bull in 1949 is sporting the 2N2 brand used by the rancher. The gentleman in the photograph is not Ned Shattuck. Shattuck was elected sheriff of Eddy County in 1923, even though he had not campaigned for the position.

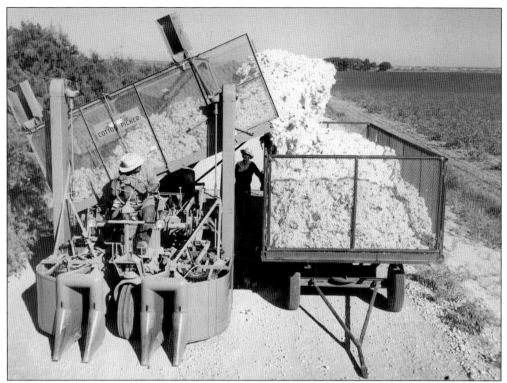

Eddy County grew all of the cotton in the State of New Mexico in 1918. Approximately one-third of the acreage of the Carlsbad Project was planted in cotton, and of those 7,600 acres, 3,325 bales were produced grossing a half a million dollars. This image shows an early-mechanized cotton picker and a recent means of transportation for the cotton haulers.

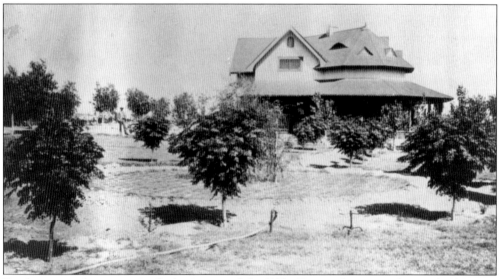

Peaches were a huge crop in the beginning of the Eddy County farming industry. Apples were the prominent crop in Hope and were said to be famous everywhere. Displays of Pecos Valley apples were consistent winners at the state fair in Albuquerque and were given as gifts to many dignitaries of the era.

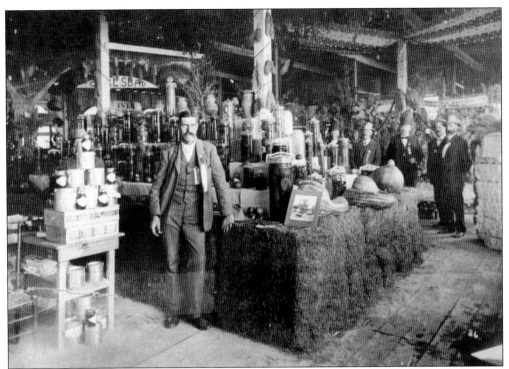

Shown in this vintage image, Eddy County's exhibit for the International Congress in 1908 won the Hearst trophy. P. Barkley is in the foreground Hovey, with the secretary of the chamber of commerce and the land man for the Santa Fe Railroad, shown on the far right.

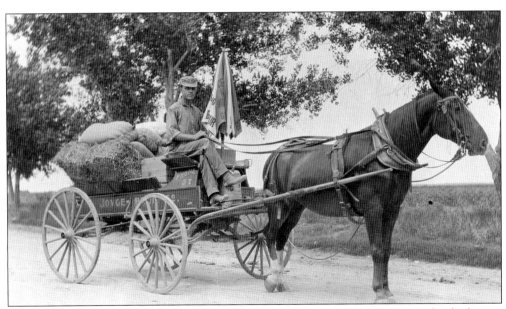

The loaded delivery wagon is for the Joyce-Pruit store, a large mercantile company that had stores located in Carlsbad, Roswell, and Artesia. The Joyce-Pruit retail company provided 43 years of personal and business necessities for Eddy County, which also included banking services.

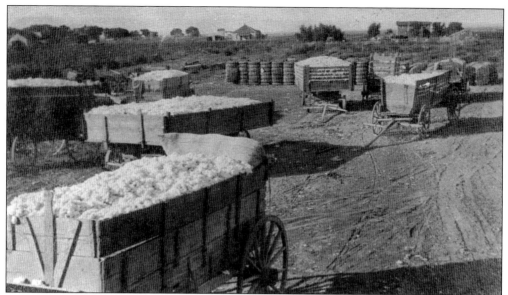

Shown in this 1916 image, wagons of cotton wait to be processed at the Otis Cotton Gin. The cotton was an Acala strain, developed in Carlsbad and Las Cruces. The first cotton gin was built in 1902, and cotton had become a major crop for Eddy County by 1918.

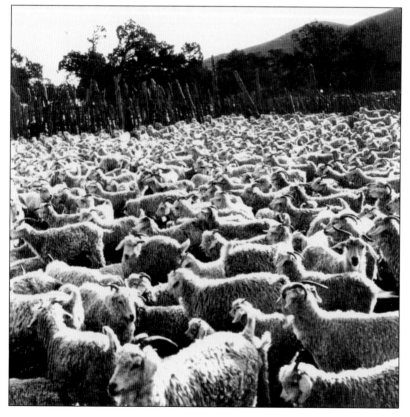

Pictured is an Angora goat herd in Last Chance Canyon, off Upper Dark Canyon, which belonged to Dave McCollaum. The fence, made from juniper and piñon branches, is very characteristic of the fences of the Guadalupe goat country in 1926.

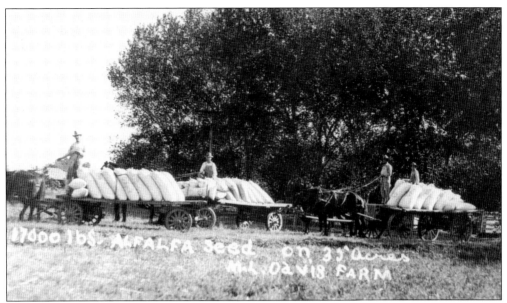

This image shows 17,000 pounds of alfalfa seed for the M. L. Davis farm. Alfalfa was the first crop to see a profit in the Pecos Valley. The irrigation of the farms was crucial in seeing this profit. A series of canals transect the Carlsbad area, carrying vital water from Avalon Dam.

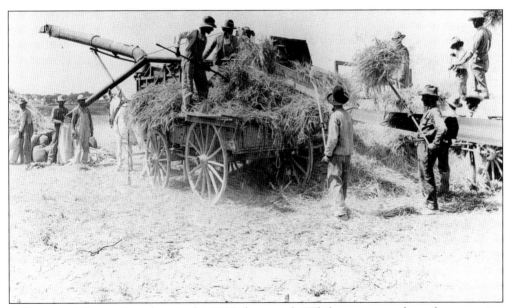

A farm crew is harvesting wheat in this 1915 photograph. While cotton was the cash crop, grains such as wheat, oats, and corn made up for the second most acreage. Cyrus McCormick invented the reaping machine in 1831, advancing the methods by which wheat was harvested.

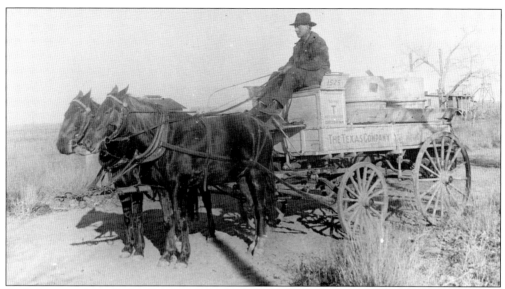

C. C. Lewis is shown hauling water on a Texas Company wagon of Carlsbad in 1915. The Texas Company was a bulk plant located at 812 North Main Street, managed by Jake Farrell. Lewis is best known for establishing the first ice manufacturing plant near the railway, located at the end of Church Street. He later became a farmer in the Otis area.

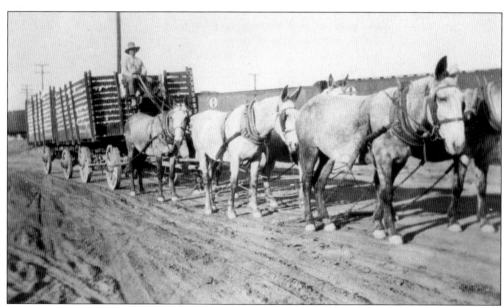

A member of the Kuykendall family from Rocky Arroyo is shown hauling cotton in a six-horse wagon. Reported by the Pecos Water User's Association in 1918, all of the cotton in the state of New Mexico was grown in Eddy County. One-third of the allotted acreage in the Carlsbad Project was planted in cotton that same year.

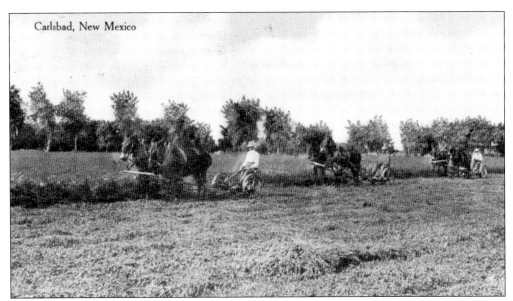

Carlsbad, New Mexico

Harvesting the alfalfa fields of the Pecos Valley was generally done four to five times a year. In the early-20th century, it took one farmer to produce enough food for two and a half people. By the end of the century, the numbers had risen to 1 farmer to 130 people.

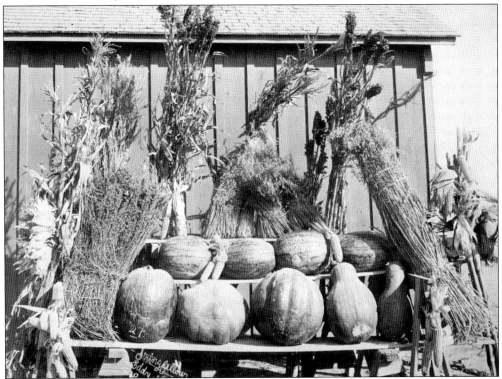

An outdoor produce display was set up beside Malaga's railroad station in 1891, which was used to entice land buyers who traveled to the area on the Pecos Valley Railroad known as Peavine, built by J. J. Hagerman. Stringfellow, who followed the Phenix group to Globe, Arizona, in 1895, took this photograph.

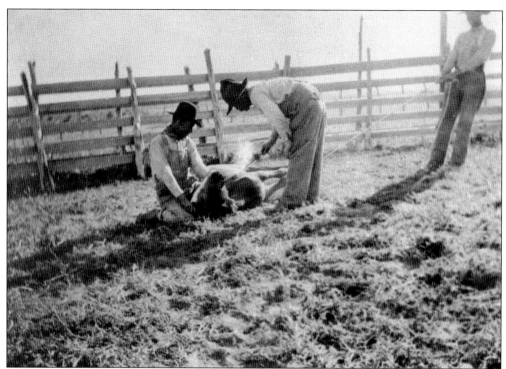

Here is mule branding on the Acrey Ranch in 1921. From left to right are Clint Acrey, "Uncle Asa," and John Acrey. The Acrey family moved to Eddy County originally from Hormony, Georgia, in 1902 and filed a squatter's claim on 300 acres in North Rocky Arroyo. They raised mules and sold 5,000 each year to the military between the years of 1910 and 1915.

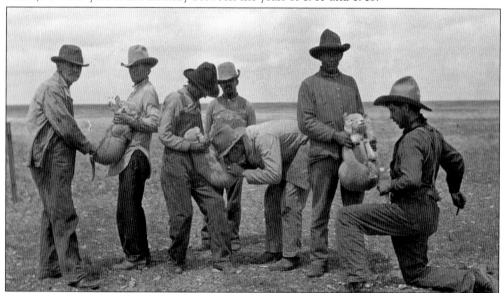

The process of sheep castration and tail docking is illustrated in this early photograph. When the male lambs reach 8 to 10 weeks old, they are separated by categories depending on their eventual use. Males that will not be used for breeding or meat, but for fleece purposes, are castrated. The first complete trainload of wool to leave New Mexico was shipped from Eddy County in June 1894.

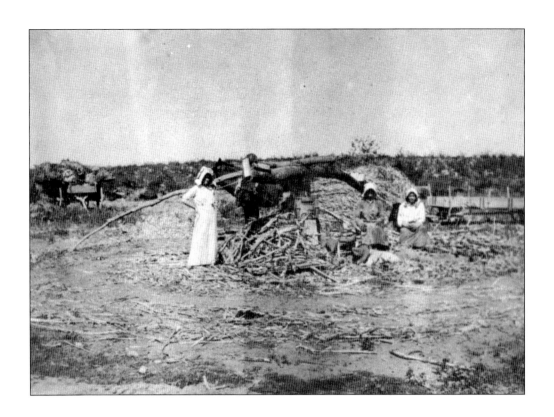

The Kuykendall family from Rocky Arroyo is shown caning and making sugar cane syrup in Rocky Arroyo in this 1910 photograph. Sugar cane is placed in a large, cast-iron kettle, which is where the cane juice is evaporated after continuous boiling for three to four hours. The juice needs to be skimmed and purified during the procedure, and lime and sulphur dioxide is added to create the greenish liquid.

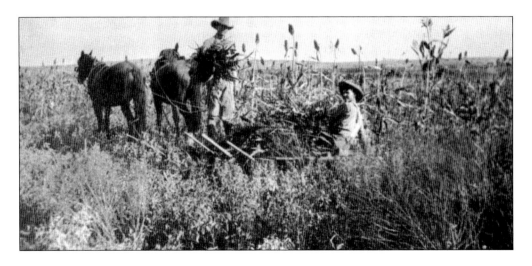

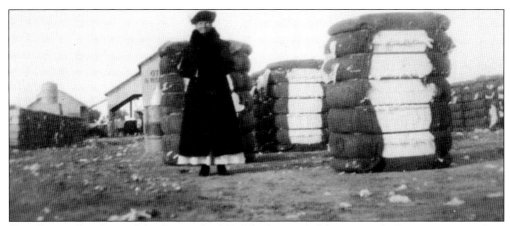

Otis Cotton Gin, located 6 miles south of Carlsbad, provided farmers with the means to get their cotton crops processed. After the cotton was cleaned and deseeded, it was placed into bales to eventually be made into clothing. The cottonseed and meal was also used to make vegetable oil products and livestock feed.

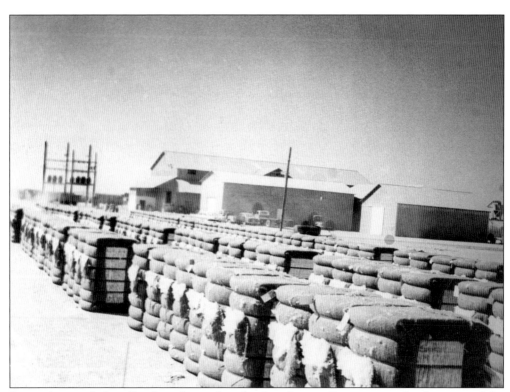

Rows of cotton-bale pallets line the yard at the Otis Cotton Gin, proving the sheer size of the cotton industry in the Pecos Valley. By 1982, the gin was processing 31,000 tons of seed per year. The gin was located next to the railroad tracks to provide early transportation to market.

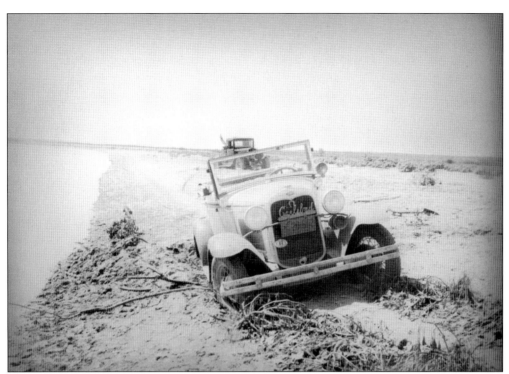

The coupe of Robert Nymeyer is stuck in the mud just above Avalon Dam in 1933. Notice the custom grill work that says "Carlsbad" on the radiator of the vehicle. Whenever it rained, the ground soaked up so much water that the soil became extremely thick, making the mud ruthless.

A steam engine for the Public Utility Company Power House is being moved to South Main Street. This photograph was taken on Greene Street in 1935. The Eddy Light and Ice Company was Carlsbad's first electric service provider in 1893.

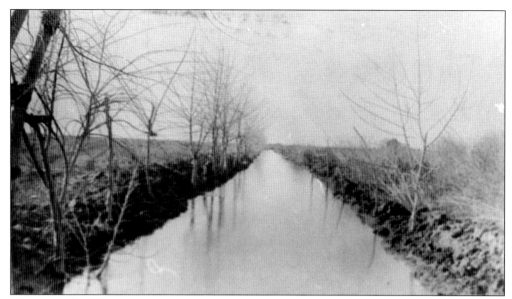

This 1892 photograph of one of the tree lined, all-important irrigation ditches, which brought the lifeblood of the Pecos River to the thirsty crops of the valley. The irrigation project, which allowed the existence of the towns of Eddy County, was one of largest in history of the United States, which is still in use today.

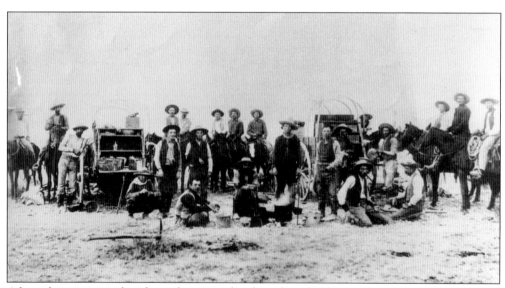

After a long season of working the range, local cowboys held a ranch rodeo to show off their skills. Some of the events were calf roping, horse races, and bronco and steer riding. In the early 1920s, rodeos were called "cowboy contests" or "cowboy tournaments." Ladies also participated by performing trick riding and barrel racing.

Five

EDDY COUNTY
CHARACTERS

As with any county, it is the people who make up and set the tone for the community. Eddy County has played host to a multitude of interesting characters that have made it what it is today. A flying paperboy, a jewelry-making Native American chief, several amateur archaeologists, a human oil dowser, and an outlaw's sweetheart are just a few of the interesting characters.

Over the years, many events and people have molded Eddy County into a progressive, productive block of land that has enriched New Mexico. Each decade saw its own celebrations and challenges, and the building blocks of the community are the citizens and their unsinkable spirits. As with every settlement, along with the good settlers came also the less-than desirable ones, who, although causing some trouble with their lawless ways, lent a touch of spice to the mix, making for some exciting times.

The dry desert air drew tubercular patients for a cure, as did the mineral springs of Carlsbad. Each of these patients had a story, and like America, the citizens of Eddy County melded, forming strong alliances. The one place where the people of the county clash is on the sport fields, as Carlsbad and Artesia battle each year in a healthy rivalry, making bragging rights a big deal for both.

No matter their reason for coming here, the people have always been hard workers in all their endeavors. Without their backbreaking efforts, Eddy County would not be where it is today—one of the leading forces in agriculture, mining, oil, gas and tourism.

During World War II, Eddy County was heavily represented as members of the 200th and 515th Coastal Artillery Anti-Aircraft. Many of these men were forced to participant in the Bataan Death March. Many Artesian workers helped to prepare the *Enola Gay* for its flight from Roswell to Hiroshima, Japan, to drop the first atomic bomb. Eddy County has seen much sacrifice suffered from its military, and these men and women will be long remembered with pride.

Eddy County played host to German prisoners of war, with camps in Carlsbad and Artesia. Congenial for the most part, the prisoners would pick cotton on local farms and hold soccer matches on Sunday afternoons.

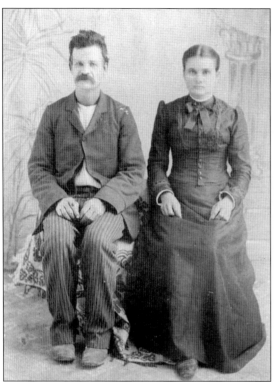

Heiskel and Barbara "Ma'am" Jones, two of the first settlers of the Seven Rivers area, raised a large family in one of the wildest towns of the Old West. Barbara, or "Ma'am" as she was more commonly known, ran a store in Seven Rivers. As one of the only people with nursing abilities, Ma'am was frequently called upon for help.

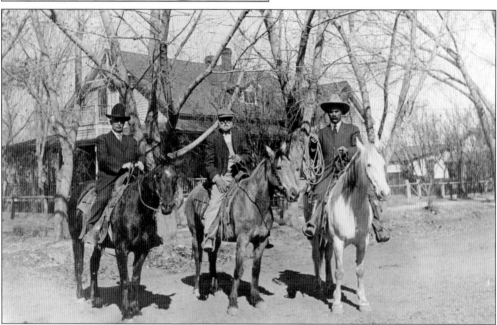

Shown on horseback in this photograph are Green Ussery (middle) and two other unidentified men. From the looks of the rope held by the man on the right, they appear to be preparing for a lynching. James Barrett, a convicted murderer of two men at the Seven Rivers dam site, was Eddy County's only incident of capital punishment. He was hanged near the Carlsbad cemetery on September 14, 1894.

Taken most likely at the Thayer X Bar ranch in the Guadalupe Mountains, cousins Marvin Middleton (left) and Walter Thayer Jr. (right), the younger brother of Ralph Thayer, pose for a photograph in 1925. The Middletons came to New Mexico in 1897 and settled in the mountains. The Thayer family initially lived in Rocky Arroyo but soon moved to their Upper Dark Canyon ranch.

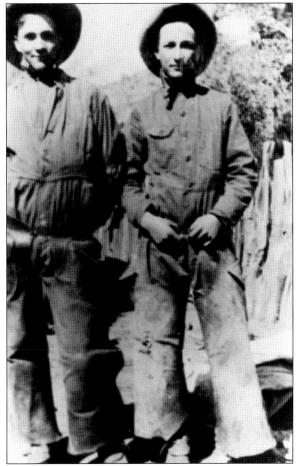

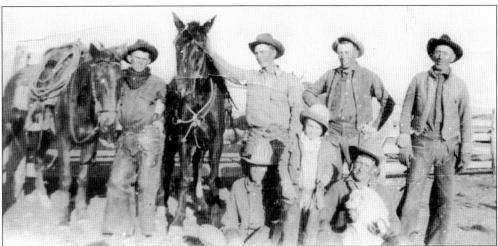

In 1927, a Bullis Springs ranching group included longtime rancher Preston Means, who was a nephew of ranch owner Johnny Prude. Bullis Springs is actually in Chaves County but skims the Guadalupe Rim with its 198 acres of deeded land and 17,802 acres of land that they leased from U.S. Forest Service.

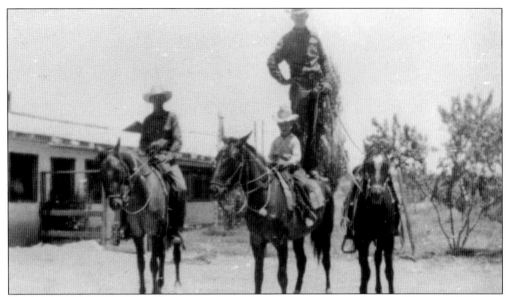

The Ballard children, pictured in this photograph from left to right, are 15-year-old Harley, 6-year-old John, and 16-year-old Thurman, standing on the horse's back.

The Stewart family strikes a pose in front of the newly constructed jail annex. Cicero Stewart, located on the right, poses with his wife, Missouri; his daughter, Ruth; and his son, Hugh. Cicero was a sheriff for Eddy County and participated in apprehending outlaw Black Jack Ketchum.

Eva Bass, along with her brother Vivian, is the picture of innocence in a brilliant, white outfit. The Bass family came to Eddy County in 1892 from Leckie, Texas. Eva recounted tales of making small figurines out of clay and letting them dry in the hot sun, since they didn't have toys to play with. Eva went on to become a teacher. (Courtesy of the Betty Bass collection.)

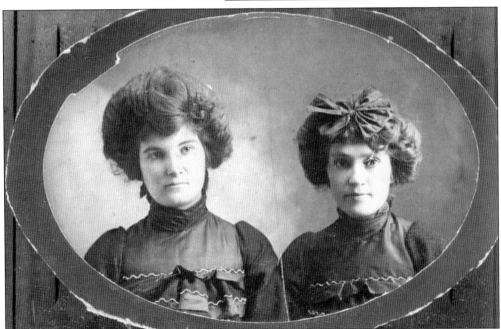

An avid hunter, Maggie Bass and her sister Susie Bass are shown in this Douglas Brothers photograph, which shows off the beautiful, billowing hairstyles of the era. The Bass family members were some of the original settlers in the Carlsbad area, making their home in Hackberry Draw, which is now known as Happy Valley. (Courtesy of the Betty Bass collection.)

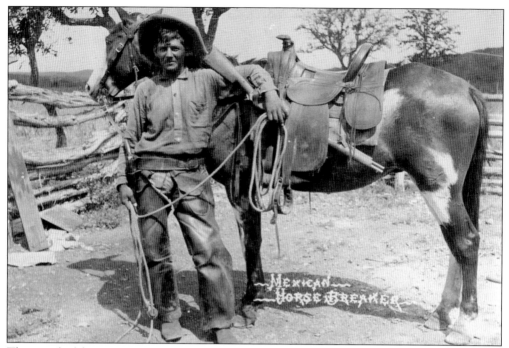

This wonderful portrait of a Hispanic horse breaker and his mount epitomized the vaquero style. The Hispanic cowboys, called vaqueros, were highly skilled horsemen and were called upon often by area ranchers to break in their stock.

A barbershop quartet poses around a campfire in this 1949 photograph. Included are, from left to right, Bill Burnett, Harry Thornberry, John Cutter, and Leon Small. Bill Burnett was and amateur archaeologist and the founder of the Carlsbad Museum, having also served as its first curator.

The Hispanic farm worker was the backbone of the ranching and farming industries of Pecos Valley. Unfortunately, little credit was given to these fine workers in their time, and without them, Eddy County would not be what it is today.

Frank Kindel, affectionately known as the "Flying Paperboy of the Guadalupes," is shown with his weekly cargo of Sunday newspapers that he delivered to the ranchers of the mountain communities through a special tube in his plane. Kindel was tragically killed on May 31, 1964, in a plane crash. The entire town mourned his loss.

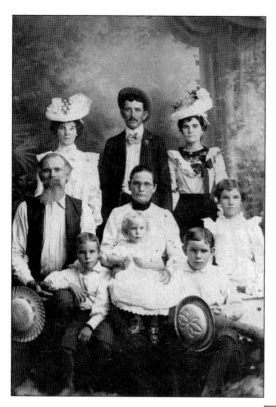

Members of the Shattuck and Bass families were pioneers to Eddy County, establishing homesteads in the Guadalupe Mountain region. Several members of these families are, from left to right, the following: (third row) Maggie Bass, Dolph Shattuck, and Susie Bass; (second row) "Papa" William Edwin Bass, "Momma" Susan Iona Chisum Bass, and Eva Bass; (first row) Clyde, Vivian, and Fred Bass. (Courtesy of the Betty Bass collection.)

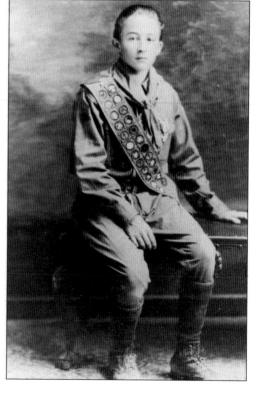

Frances Tracy Jr., Carlsbad's first Eagle Scout, proudly poses with his 21 badges that were required to obtain the honor. Beginning in 1911, a Boy Scout who has been a Life Scout for at least 6 months can work toward the much-coveted rank of Eagle Scout.

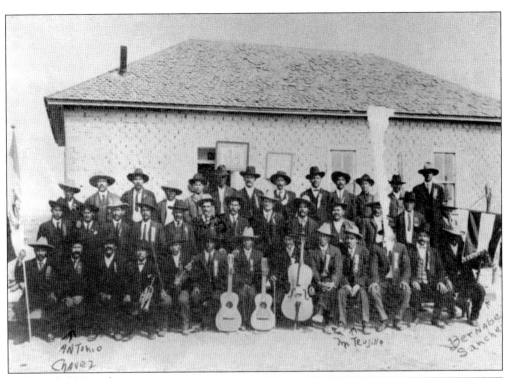

La Sociedad Mutualista Mexicana of San Jose was established in 1907. This 1910 photograph shows members included Antonio Chavez, Artazo Moralez, a gentleman identified only as Mr. Trujillo, and Bernabe Sanchez.

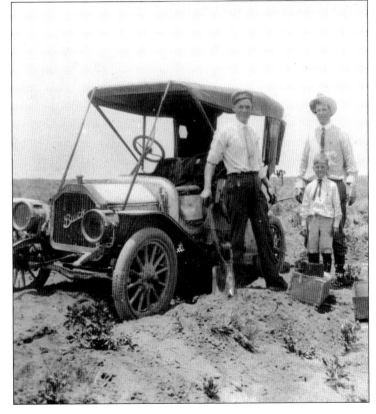

Will Merchant and his son Bill are pictured on the right beside their car that was stuck in the mud. The helper is unidentified. Even though Eddy County is primarily in a drought situation most of the time, when it does rain, the earth becomes treacherous, producing thick, unforgiving mud.

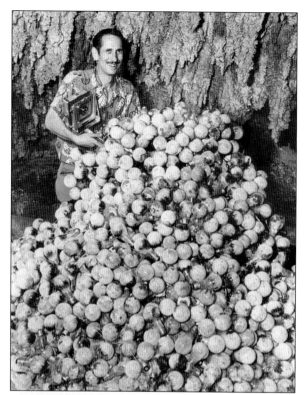

Pictured in 1948, Ennis "Tex" Helm, an innovative photographer of the Carlsbad Caverns sponsored by Sylvania, used in total 2,400 light bulbs while trying to get his famous August 19, 1952, "Big Shot," which was of the Big Room. Shown is the small mountain of those spent light bulbs from this one session. Connected to 3 miles of cable, it took 16 hours to set up and tear down the scaffolding, cables, and equipment necessary to get the photograph, which created the "most vivid flash since the atomic bomb detonation in 1945," covering an estimated 555,000 square feet.

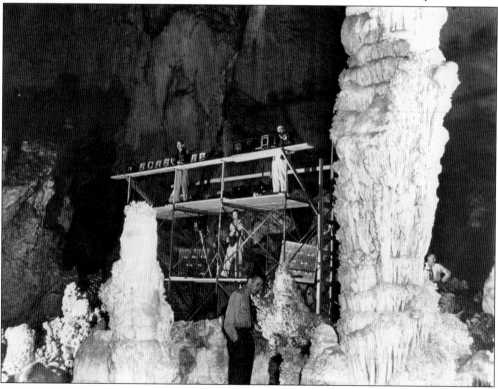

Sallie Chisum, the niece of famed cattle baron John Simpson Chisum, was known as the "First Lady of Artesia" due to her establishment of a post office and stage stop, which eventually became Artesia. Sallie is shown with her brothers, Walt and Will, in the top photograph, taken on Sallie's 16th birthday. The photograph below shows Sallie with what is thought to be Will. She is riding sidesaddle—her signature style in a parade—most likely in Roswell. (Right, courtesy of HSSNM #2199; left, courtesy of HSSNM #1849 from the University of Oklahoma Rose Collection.)

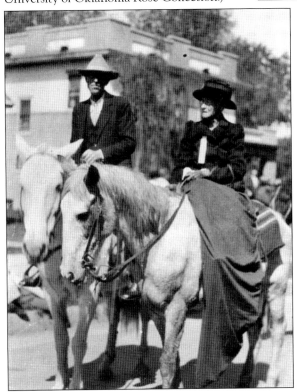

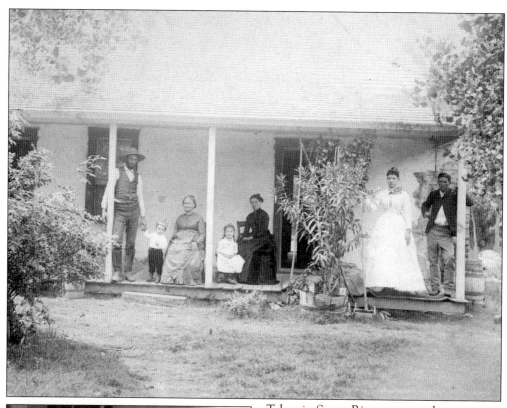

Taken in Seven Rivers, soon to be Lakewood in 1888, this photograph shows members of the Fanning, Larrimore, and McDonald families lounging on the porch of the "Linger Longer Ranch," which served as a stage stop. Guests would want to stay longer and longer to enjoy Sarah Fanning's wonderful meals, hence the name. (Courtesy of the Betty Bass collection.)

Dee Harkey, author of *Mean as Hell*, told the story of early Eddy and its sister town, Phenix. The book sparked controversy amongst some residents who questioned the validity of the tome. The book serves today as a rare glimpse into the Western way of life.

Six

BLACK GOLD, SALT OF THE EARTH, AND TOURISM

With the eruption of Illinois No. 3 on Christmas Eve of 1920, the complexion of Eddy County would never be the same. During the early 1920s, the drilling industry shifted the focus from water to oil, making many county residents prosperous, with the first paying well being established in 1924. A steam-powered cable tool rig did the drilling. Although the first few wells drilled were dry, the next was a gas well that couldn't be developed at the time, so it provided the equipment with energy. Natural gas was said to have been an "elastic commodity" due to supply and demand fluctuations in the beginning.

Van Welch, Tom Flynn, and Martin Yates were the premiere oilmen of the Permian Basin and developed an oil business that still operates today. The most productive well was drilled near Artesia in 1909. It was first named the "Hammond" well and later changed to the "Brown," which produced oil at 900 feet. Compared to today's production numbers, its yield of only 6 to 10 barrels a day seems like a pittance, but in 1911, it was a good start. By 1925, the numbers had risen to 25 barrels a day.

Carlsbad got into the act in 1926 when the first well, named the "Getty Shallow," was drilled 12 miles east of town. It was through these efforts that the largest deposit of potash was accidently discovered by geologist V. H. McNutt in 1925. It was reported that the government had been searching for potash in the Carlsbad area since as early as 1910 due to a shortage during World War I, which was when most of the world's potash was obtained from Germany.

United States Potash Company was the first mine to open in the Permian Basin, but the first mine shaft was not sunk until 1930, and the first commercial grade ore was mined and refined in 1932. It is reported that in order to find water in the Eddy (later Carlsbad), an English geologist was brought in to predict a location, which he did using an Ouija board. During his study, he predicted the discovery of a massive deposit of potash—so large it might be valueless. Luckily, the second part of his prediction turned out to be false.

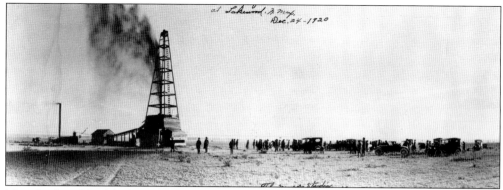

Moss Studio of Carlsbad captured the shooting of the Illinois Producers well No. 1 at Lakewood on December 24, 1920. It was a 30-second eruption of petroleum. The owners of Illinois Producers well No. 1 and founders of Illinois Camp were from the state of Illinois and named everything they owned after it.

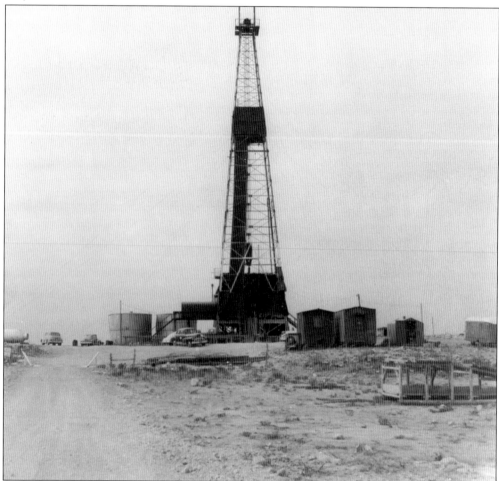

This unidentified oil rig was typical of the many that dotted the Eddy County landscape. Used for core testing or actual drilling, the oil rig is still as much in view now, as it was in 1926. The first well near Carlsbad was the Getty Shallow well, which was about 12 miles east of the city.

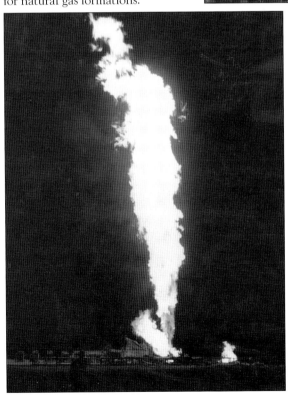

Here are two spectacular views of a natural gas well blowout in Indian Hills, amidst the vast oil and gas fields between Carlsbad and Queen. The explosion occurred in December 1962 and continued until January 1963. These types of blowouts generally happen when the pressure control system fails. The limestone rock formations of the Guadalupe Mountains provide perfect pockets for natural gas formations.

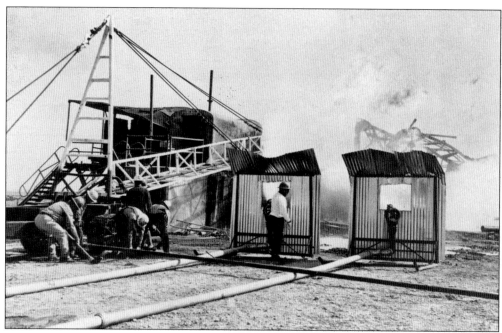

Famed oil field firefighter Red Adair, pictured in the center of this photograph, was called in to extinguish the flames of the Indian Hills blowout in Rocky Arroyo. Known as the best in the business, Adair was extremely busy putting out an average of 42 fires a year, learning his skills from the 139th Bomb Disposal Squadron in World War II.

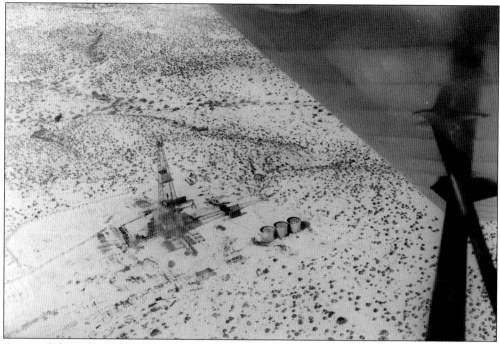

An aerial shot of an Eddy County oil rig in 1948 is just one example of the enormous amount of rigs operating in the county. The tank battery, shown to the right of the oil rig, is where the oil is tested and measured before it goes into the pipeline system.

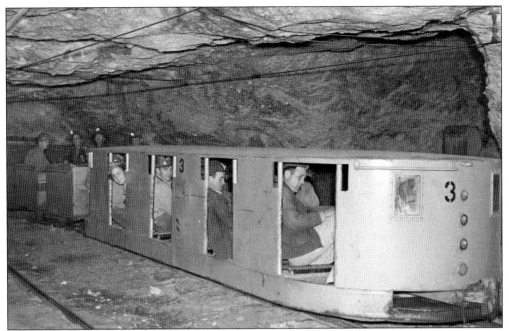

A loaded mantrip, also called a "truck jeep," is used to shuttle potash miners to their work zones. Basically, a small train traveled along two rails, working as a cable car system. Some ran off of diesel engines, which meant miners traveled to the mine backwards. With its protective roof, the one shown is fancy for 1949.

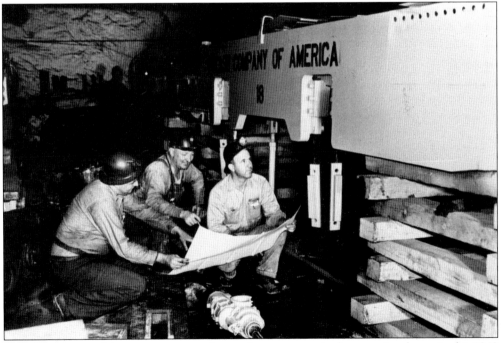

Potash Company of America engineers discuss the new motorized ore carrier, shown in this 1949 photograph. These carriers are used to pull potash ore out of the mine, so it can be processed and transported by train to its final destination.

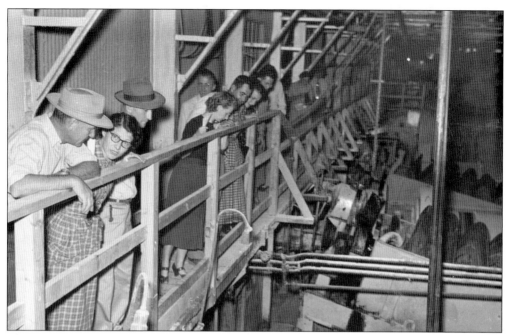

The annual open house of Potash Company of America brought crowds from around the county to personally see how the potash mining operation works. Before the late 1940s, the mines were very secretive. Tours and photographs were not allowed, since the early mining equipment was in the process of being invented.

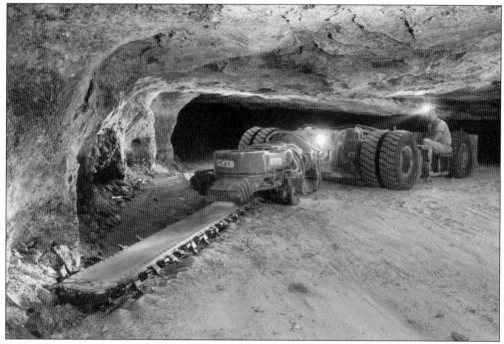

A piece of machinery called an under-cutter is used to cut approximately 6 inches under the face of the potash ore to prepare it for blasting and loading out. Once the face is cut, it is blasted with dynamite, causing the entire cut piece to fall and break apart.

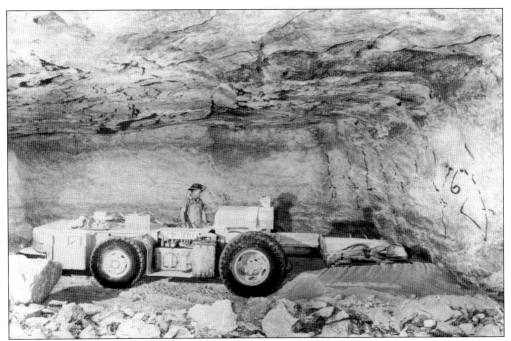

Here is another photograph of an under-cutter in action, as it slices into the potash ore along the face. The vertical lines along the face are blasting holes, and the number 16 that is written on the face gives the machinery operator an indication as to how far to cut.

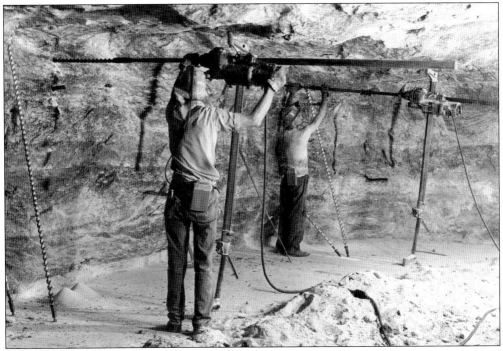

Standing drills are being used by the potash miners to drill into the face of the potash ore. Much of the machinery used in the early potash mines were invented and developed in Carlsbad. Because of this fact, early photographs were strictly limited.

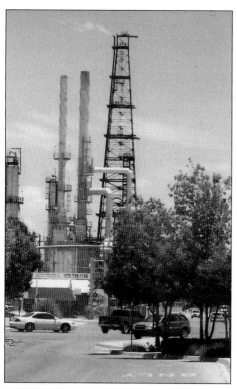

Navajo Refinery, owned by the Holley Corporation, is the major employer of Artesia with its 100,000 barrels per stream day capabilities. Situated on 561 acres in the center of Artesia, the group of refinery stacks is a landmark that can be seen upon entering town from any direction. Refined products are distributed to Arizona, New Mexico, West Texas, and Northern Mexico through pipelines.

The Waste Isolation Pilot Plant (WIPP) was established in Carlsbad to provide a waste storage area, located 2,150 feet underground in the stable salt formations. Mainly transuranic waste (low-level) such as clothing, tools, rags, and disposable items contaminated with trace amounts of radioactive elements are stored in the facility.

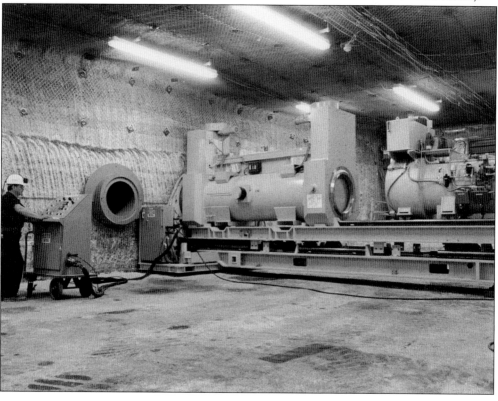

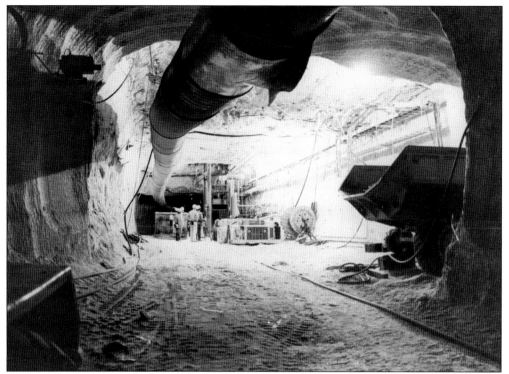

The tunnel, or drift, of the Waste Isolation Pilot Plant provides access to the storage rooms cut out of the salt formations that are designated for that purpose. All pieces of equipment and workers must be lowered by elevator. The dump truck shown had to be lowered and reassembled one piece at a time.

The TRU-PACT truck, pictured here, carries the low-level waste from the original sites to the Carlsbad facility. The waste is transported in reusable, double-contained, stainless steel containers, and the trucks make an average of 850 shipments annually. TRU-PACT is the acronym for TransUranic PACkaging Transporter. Each container can hold up to fourteen 55-gallon drums of waste.

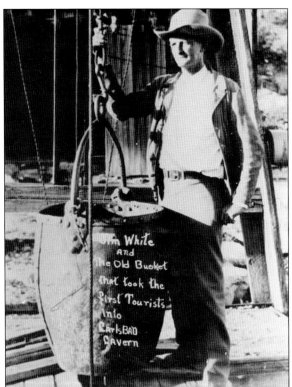

Jim White is shown with the guano bucket, which first took tourists into the Bat Cave. White promoted the cave until it gained the attention of the federal government. It was turned into a National Monument on October 25, 1923 and a National Park on May 14, 1930.

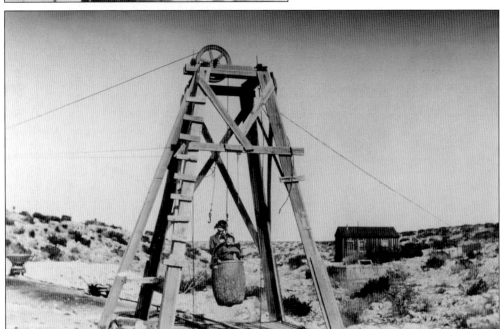

Jim White Jr., affectionately known as "Jimbo," rides with Ann Lee, the daughter of geologist Willis T. Lee, into the Bat Cave in a guano bucket that is lowered by a pulley system in 1928. The buckets were used to bring bat guano to the surface by miners, such was done by early mine owner, Charlie Doss, who operated the mine in 1907.

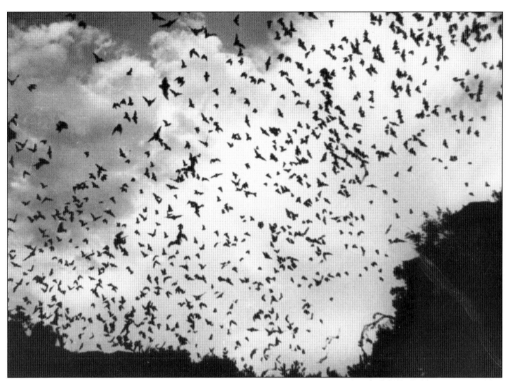

A dramatic photograph of the bat flight shows the enormous numbers of the mammals that call the Carlsbad Caverns National Park home. Tourists to the cave are treated with an annual bat flight breakfast each summer, which allows them the rare opportunity to watch the bats returning to their cave after a night of feasting on insects.

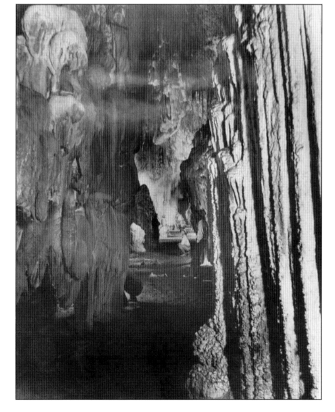

An early photograph of beautiful draped formations, taken by local photographer Ray V. Davis, gives the viewer the immense beauty of the cave. A recently relayed story tells of a guano miner, believed to be seen on the right-hand side of this photograph, who did not like to show his face due to the fact that he was thought to be an outlaw, known only as "Tex."

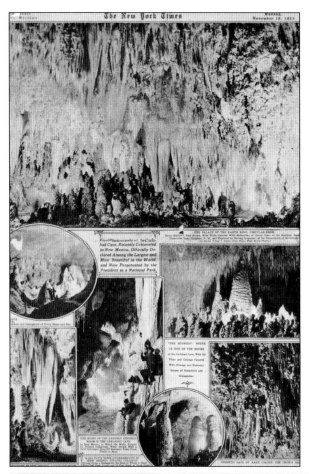

The 1923 *New York Times* featured an article about the Carlsbad Caverns that was highlighted by the photography of local photographer Ray V. Davis. It was through this article that much of the country got their first taste of the wonders beneath the desert landscape.

Spectacular formations, known as totem poles, are shown in this Ray V. Davis photograph. This area of the cave is known as the Bat Cave, as was the entire Carlsbad Caverns before it was officially named in 1930. The first wedding ceremony was held June 23, 1927, at one of the most famous of all formations, the Rock of Ages.

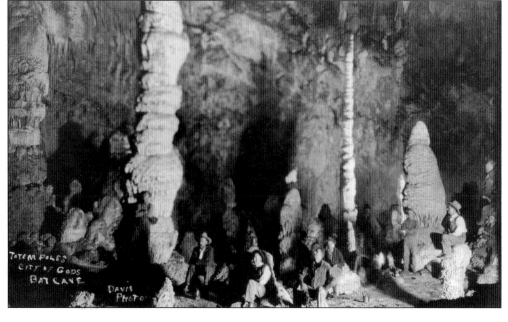

Seven

EARLY ARCHITECTURE

Eddy County started out with the same structures that many Western towns started out with—tents. Graduating to plank boards, the tiny towns began to grow into the bustling communities they are today. Because of the lack of supplies in the immediate area, a trip to Toyah, Texas, was necessary. To reach a railroad, these trips were expensive and sometimes dangerous. The materials for the first structure in Eddy (Carlsbad) were brought by wagon train from Trinidad, Colorado, over 300 miles away.

As Carlsbad grew, more homes were built to accommodate this growth. With each home, a tradition of throwing the homeowners a dance threatened to exhaust the townspeople. The late 1940s and 1950s saw a postwar boom, which brought growth to both Carlsbad and Artesia. New houses, churches, banks, schools, and stores sprang up, which seemed to have occurred overnight.

The first buildings in Artesia were made from wood, but they boasted hot and cold running artesian water. Many of the earliest structures in Eddy County were made of adobe, which was a building material readily available. As the Pecos Valley Railroad made the transportation of construction materials more economical, the homes and businesses of the county began to reflect this fact. Stone, concrete, and brick were used more often.

Carlsbad had its own brick factory, which used local resources for materials. Unfortunately, the bricks proved to be of a poor quality, often the structures built from them to have to be torn down. One of the few buildings remaining that used this brick is the First National Bank Building, now the Trinity Hotel. Major renovations have successfully been done to secure the Trinity Hotel's integrity, making the building the last surviving structure of that era.

Downtown Eddy looked like a typical Western town with wooden buildings and sidewalks. Paving was not done until much later, so dust and mud were a constant headache for residents. Hitching posts were a common sight in town, even after the arrival of the automobile.

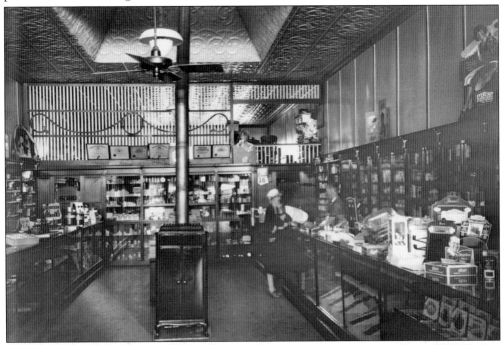

Here is the interior of Star Pharmacy at 122 South Canyon Street in 1927. Owner Harry Braden chats with customer Mrs. Robert (Ollie) Halley over the gleaming glass counter top. The recessed tin ceiling was a unique feature to the two-story drugstore.

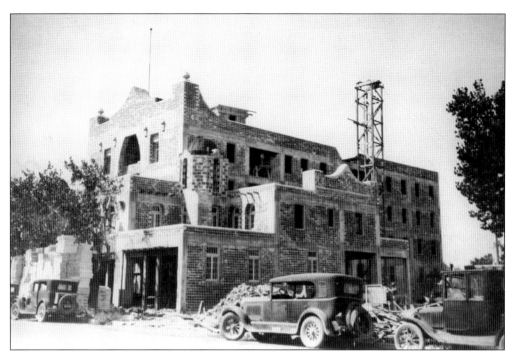

Located at the intersection of Highways 62 and 285, the La Caverna Hotel, built in 1927, played host to many cave explorers, dignitaries, and travelers. Architect Henry C. Frost, of El Paso, Texas, left his imprint on nearly 300 buildings in the Southwest, and this is one of two in Carlsbad that he designed. Unfortunately, the Coronado Wrecking Company tore down the La Caverna on February 1, 1980. All but the banquet facilities were razed, which were eventually turned into the My Way bar, which was torn down in the late 1990s. A historical mural, painted by Herndon Davis, hung in the La Caverna for 50 years before it was moved to the Carlsbad Public Library and then, most recently, to the Pecos River Conference Center.

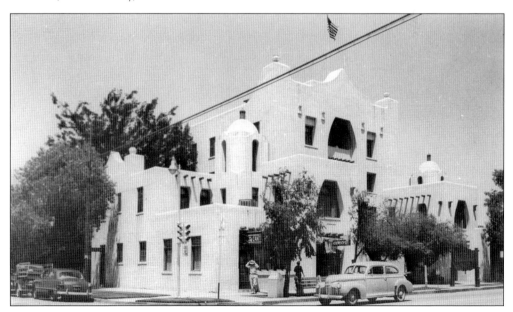

The First National Bank Building of Eddy, which is at the corner of Fox and Canal Streets, is shown in its heyday in 1917. It has been an enduring symbol of history in Carlsbad, having been completed in August of 1892. The convergence of the automobile replaced hitching posts with parking spaces. The building has recently been completely restored to its original glory and now houses the Trinity Hotel.

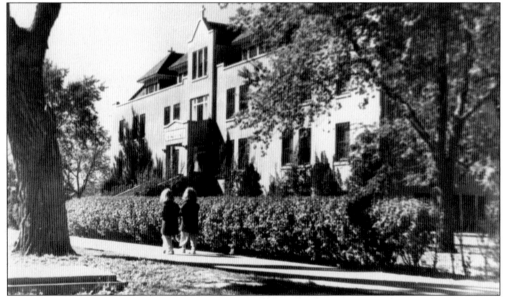

The St. Francis Hospital of Carlsbad is shown in this 1949 photograph. The women of town formed the Eddy County Hospital association in 1898, renting a four-room building until 1905, when they acquired a two-story frame building, which housed 10 beds. Sisters of the Order of the Adorers of the Most Precious Blood opened a small sanitarium that was enlarged to a general hospital in 1917.

Eddy's first school building was made of adobe brick in 1889 by the Pecos Valley Town Company. Immediately upon completion, it became overcrowded, and a new stone school was built that fall.

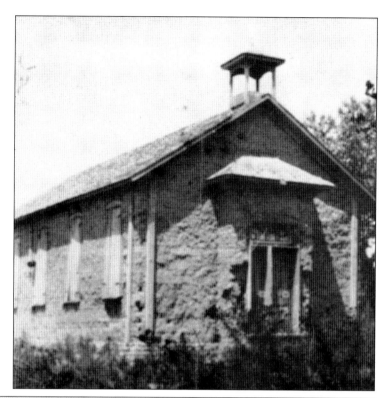

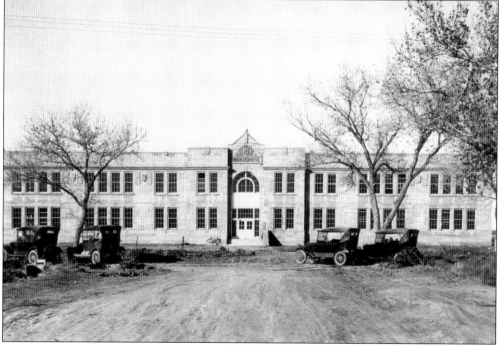

Shown in this 1908 photograph is the first Carlsbad High School, built that year. This building would later become known as Mid High School and house ninth and tenth grade students. The school is currently named P. R. Leyva Middle School, which is in honor of a beloved biology teacher.

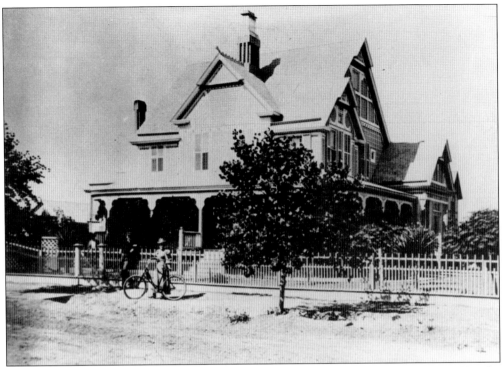

Photographed in 1897, this home located at 601 North Canal Street was built for Mr. Miller, the first railroad manager of the Pecos Valley Railroad. The Miller home was known as one of the largest, with three stories. It would become the home of Ralph Thayer.

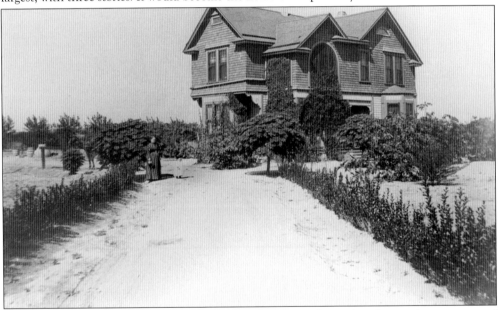

The Draper house, later to become the Mudgett home, was located at the northwest corner of Cherry Lane and Canal Streets in La Huerta. Lottie Draper and her young daughter Mary Ann are shown in this 1895 photograph. The Drapers were Texas ranchers whose ranch was located far to the east, near the Texas border.

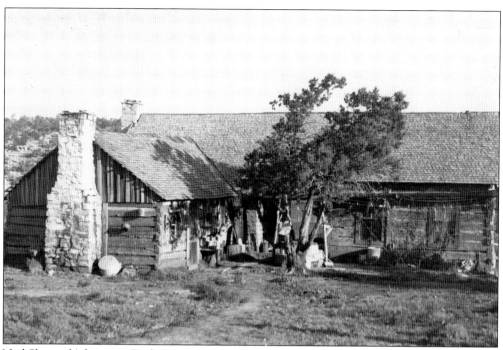

Ned Shattuck's home in Dark Canyon was constructed with logs and limestone for the fireplace chimney. Shattuck had a large extended family and would hold picnics and barbeques often.

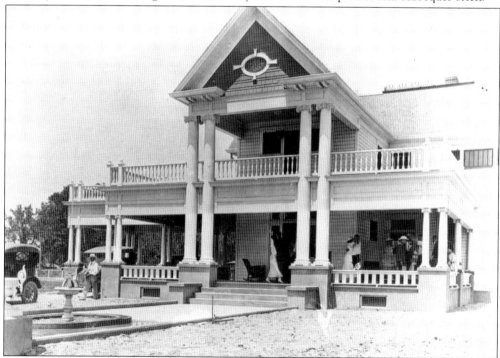

This impressive Southern-style mansion, owned by Carl Livingston, was located in the middle of a cotton field on Canal Street in Carlsbad and was the setting for many social events. A tank sprinkler was used each day in an attempt to settle down the dust from the streets.

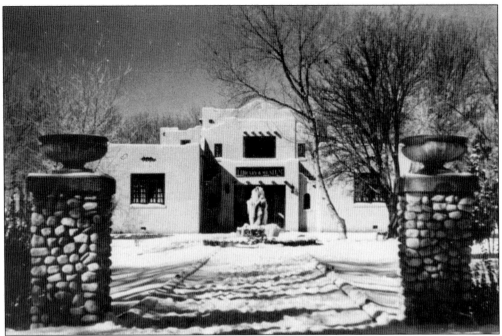

The Carlsbad Public Library at 101 South Halagueno Street was a winter wonderland with its frozen fountain in this 1933 photograph. An unusual cold snap lowered the temperature to -4 degrees and reportedly killed most of the shrubs in Carlsbad that year. The part of the pueblo-style building, which was built in 1930 at the cost of $20,000, now houses the children's department.

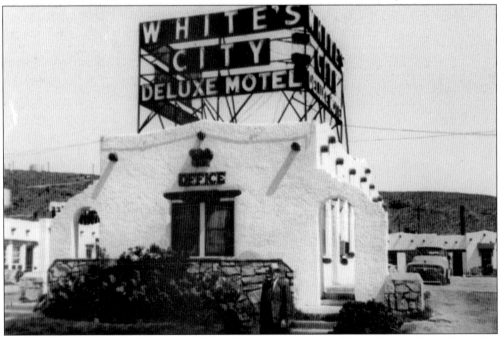

White's City is the gateway to the Carlsbad Caverns National Park and has had several motels over the years to serve the tourists who come to see this beautiful attraction. Shown in this 1937 photograph is one of the first motels built on that location. Some of the motels still stand today.

Eight

PECOS VALLEY ART

Artesia has been graced by the additions of beautiful bronze sculptures that dot its main intersections, depicting the importance of the ranching culture and oil industries to Artesia. These art pieces are part of the Artesia Main Street's History in Bronze Series, which is mostly privately funded.

The Heritage Walkway, which is also in Artesia, filled a lot vacated by a building fire in 1976. As with many communities across the country, Artesia found ways to celebrate the country's bicentennial. The Artesia Junior Women's Club and a local art teacher decided to transform the lot into an artistic center by creating two murals along the south wall. These murals were joined in 2004 by a mural painted by local artist Noel Marquez. All of these murals highlight the community's heritage.

A stream meandering through the park is completely lined with handcrafted tiles by ceramic artist Shel Neymark of Embudo, New Mexico. The tiles depict every aspect of the cotton industry. Other water features, scattered throughout, represent eight Artesian wells, which provided not only the much needed water source but also Artesia's name. Iron gates on either end of the walkway were created with intricate metal artwork by Carlsbad welder and artist, Debbie Rottman.

Carlsbad's Halagueno Art Park, which surrounds the Carlsbad Public Library and Carlsbad Museum and Art Center, features works by noted sculptors such as Glenna Goodacre and Wren Prather. The *Navajo Woman and Child* was the first sculpture acquired by art patron Frances Feezer, followed by *Ollie* the skateboarder, and *The Secret*. In celebration of the library's centennial, Wren Prather was commissioned to create a larger-than-life piece entitled *The Reader*.

Above the library annex portico is a mural entitled, *Dream of Sunday Afternoon in Halagueno Park*, which gives a colorful depiction of Carlsbad's history by the same artist who illustrated Artesia's history, Noel Marquez.

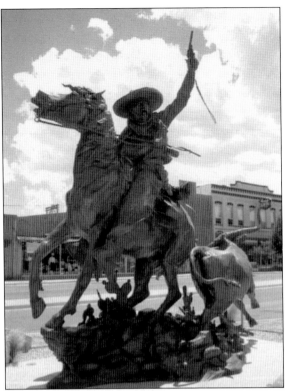

The Vaquero (cowboy) was created by Mike Hamby and unveiled in Artesia in 2008. Located near the famed La Fonda restaurant, *The Vaquero* shows off his skills as a cowboy and has spotted *The Rustler* a short distance away. (Courtesy of James Owens.)

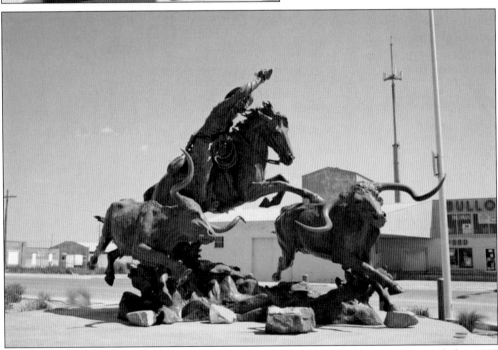

The Trail Boss by Vic Payne at the corner of First and Main Streets in Artesia was unveiled in 2007 and depicts the owner of a small herd driving his longhorn cattle to market. Called to action by *The Vaquero, The Trail Boss* moves his herd out of danger. (Courtesy of James Owens.)

Lady of Artesia is a statue of Sallie Chisum, who was not only the niece to cattle baron John S. Chisum but also the rumored sweetheart of Billy the Kid. The statue is reading a book, *The Authentic Life of Billy the Kid* authored by Patrick Garrett, to two eager children in this 2003 Robert Summers monument. Sallie was known for her great love of children and business sense, while establishing and opening the first town's post office. (Courtesy of James Owens.)

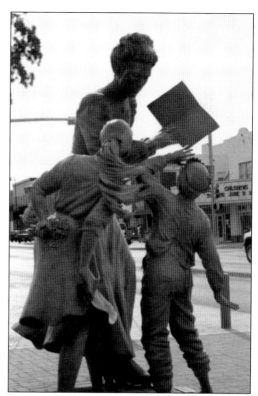

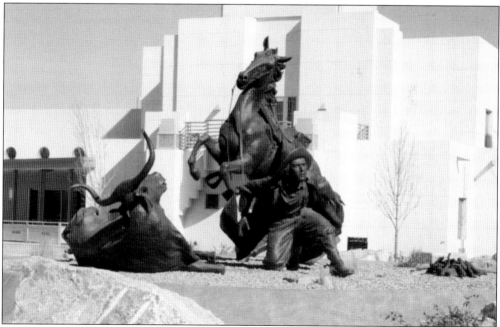

The Rustler by Robert Summers is the most recent addition to Artesia's Cattle Drive series and was completed in 2009. With a calf down and poised for a gunfight, the young cowboy is preparing to steal cattle to sell as his own to unsuspecting buyers, when he sees *The Vaquero*. It is thought Billy the Kid was the inspiration behind the sculpture. (Courtesy of James Owens.)

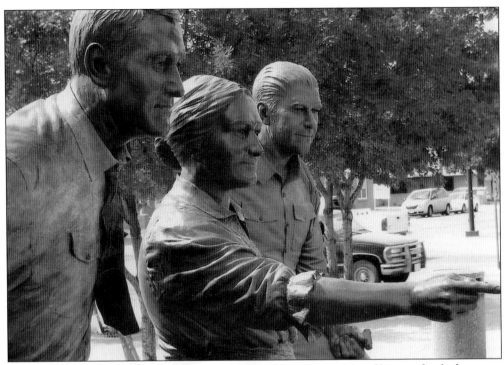

Mary Yates, wife of oilman Martin Yates, had an uncanny knack of sensing where an oil deposit would be, a talent the oilman was thrilled to utilize. The statue, entitled *Woman's Intuition* by Vic Payne, illustrates Mary plying her magic as she points to a potential drilling spot. Also shown with the Yateses is their partner, Van Stratton Welch. (Courtesy of author's collection.)

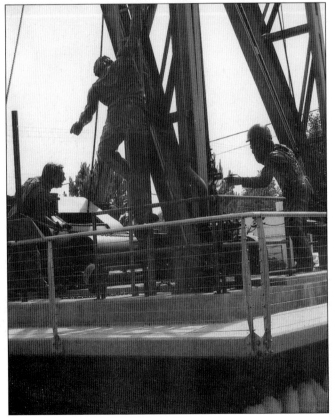

The Derrick Floor by Vic Payne depicts the daily duties of oil rig workers—roughnecks—who work long hours and put their lives in jeopardy everyday to bring forth the energy source that fuels the world. Done in 125-percent life size, this imposing sculpture also serves as a fountain. (Courtesy of author's collection.)

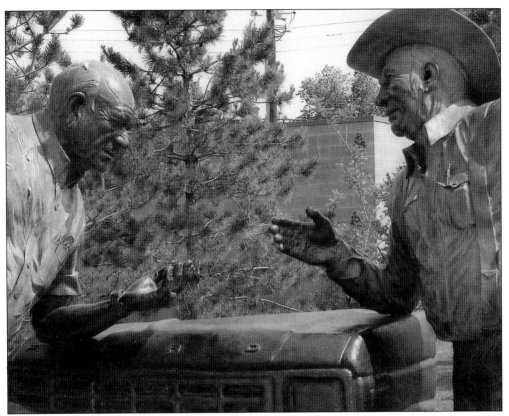

Mack Chase and Johnny Gray are represented in this bronze entitled *Partners*, which was also created by sculptor Vic Payne. Shown discussing business over the hood of a pickup, the pair was successful in forming an oil company, which would produce 2,700 barrels of oil per day. One of the companies, Marbob, is still in operation today. (Courtesy author's collection.)

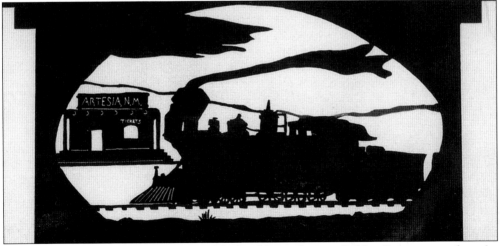

Iron gates created and installed by Carlsbad welder and artist, Debbie Rottman, enclose the Heritage Walkway in the heart of Artesia. The top railings of the fences are intricate metal cutwork silhouettes that tell the history of Artesia, and scenes from the railroad and oil fields are featured among these silhouettes. (Courtesy of author's collection.)

Colorful murals grace the walls of the Heritage Walkway. The left photograph is an example of the mural painted by the Artesia Junior Women's Club and a local art teacher. This mural shows the evolution of ranching in Artesia. Local muralist, Noel Marquez, created the mural in the photograph below in 2004. Both walls of the walkway illustrate the community's history. (Courtesy of author's collection.)

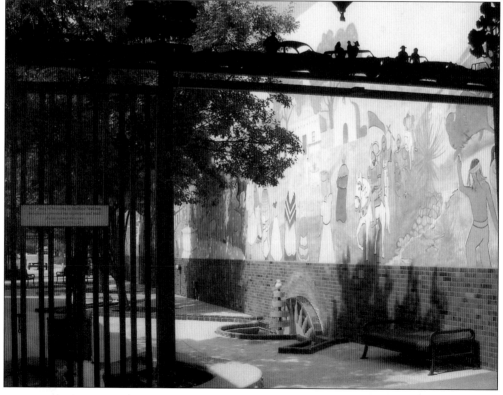

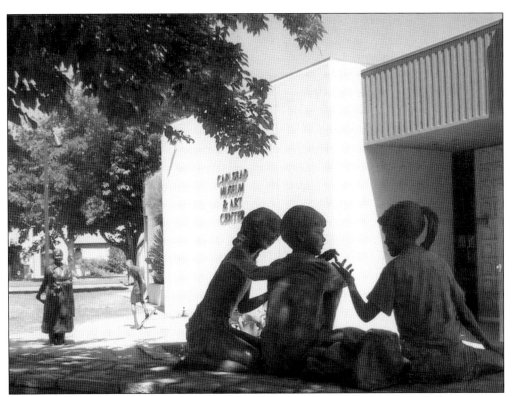

Thanks to museum benefactor, Frances Feezer, the Carlsbad Museum and Art Center grounds are beautified by three statues by acclaimed sculptor Glenna Goodacre. Featured in this grouping are *The Facts of Life*, *Dance Day*, and *Ollie*. (Courtesy of author's collection.)

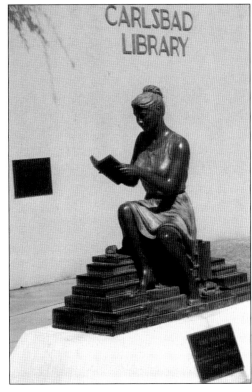

The Reader by sculptor Wren Prather complements the Carlsbad Public Library front walkway. Commissioned for the library's centennial in 1997, the statue, done in 125-percent life scale, sits upon a pile of books with local interest titles. The town's children enjoy reading over her shoulder. (Courtesy of author's collection.)

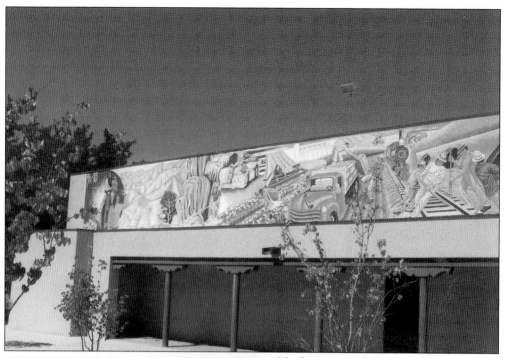

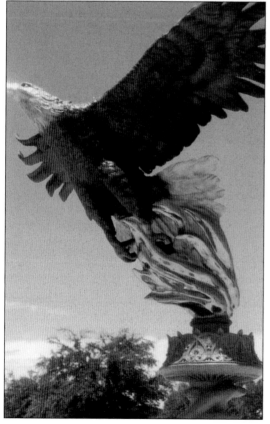

Noel Marquez of Artesia created a beautiful mural over the portico of the Carlsbad Public Library Annex, which follows the history of Carlsbad and its people. Mariachi bands and dignitaries unveiled the mural, which will be a highlight of the Halagueno Arts Park for years to come. (Courtesy of author's collection.)

The newest bronze creation in Artesia is entitled *Freedom's Fire* by artist Beverly Paddleford from Lander, Wyoming. The sculpture will be the center of the newly planned City Hall Campus Plaza. The Eagle Bronze Foundry is a family owned enterprise and is known for its excellence of work. (Courtesy of author's collection.)

Nine

MEMORY LANE

Social activities were vital to the development of Eddy County. With low populations, civic groups, run mostly by women, were instrumental in making the needed improvements in the communities. It was through their efforts that libraries and hospitals were built using funds raised by chicken pie suppers and door-to-door donation campaigns.

Since its inception, Eddy County has seen its share of events and characters that have molded the county into an extraordinary place to live.

In addition to clubs, cultural events were also present in the county. Opera companies gave performances in barns and used hay bales for seating. Later Robert Tansill, a founding father of Carlsbad, built a large, red brick opera house on the corner of Mermod and Canal Streets for the use of the residents. Even lowly Phenix had its own opera house in an attempt to make the town legitimate, but sadly this gave way to the saloons.

Horse races and rodeos provided an afternoon's fun for the gentlemen of the county. A level racetrack, used by competitive cowboys betting money, was opened at the intersection of Mesquite and Stevens Streets in Carlsbad.

Artesia residents enjoyed ice cream suppers held in a vacant lot on the corner of Roselawn and Main Streets. These events would find everyone dressed in their finest attire, as they enjoyed the festive decorations and listened to O. J. Adams lead the band. There were also dances and receptions held at the Commercial Club Building on Main Street. It was written that the ladies of Artesia would only receive callers on regular "receiving days." Although this was the West, the townspeople strived to maintain a sense of formality, which harkened back to their Eastern roots.

Eddy County has seen dignitaries such as William Jennings Bryan and Carrie Nation, who have delivered speeches in both Artesia and Carlsbad. Both these cities were home to astronauts. Edgar D. Mitchell, pilot of the lunar module for Apollo 14, hails from Artesia, and Drew Gaffney, doctor and payload specialist on board the Space Shuttle *Columbia*, grew up in Carlsbad.

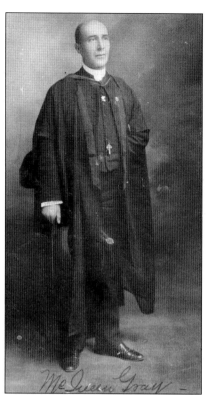

Edward D. McQueen Gray was an Englishman who came to Carlsbad around 1895. McQueen was a poet and later became the president of the University of New Mexico in Albuquerque from 1910 to 1912. While living in the Carlsbad area, he had a white-columned mansion on the corner of Stevens and Canal Streets and had a country estate known as Crofton Hill, near Loving.

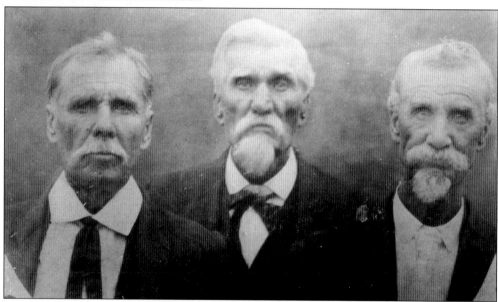

The McDonald brothers, shown from left to right, are Gus, Monroe, and Robert Lafayette "Lafe." Lafe's wife's name was Alwida Joy McDonald, and her mother's name was Elizabeth Joy. They were ambushed and killed by Indians on their way back from visiting a neighbor. After the tragic death of Lafe's wife and mother-in-law in Gillespie County, Texas, the family moved to Eddy County, which is where he later remarried to Amanda Larrimore. Their son was a sheriff at the time of Bonnie and Clyde.

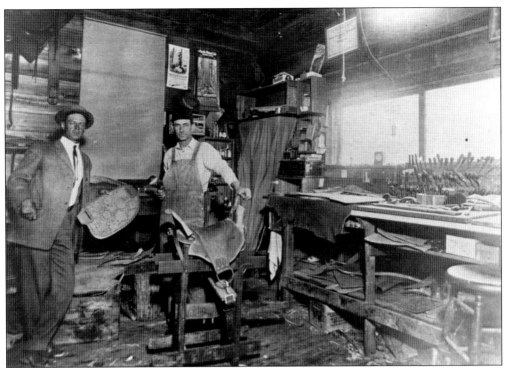

Edward "Kirk" Kirkpatrick was said to have been the "Southwest's greatest saddle-maker." While being employed by the Roberts-Dearborne Hardware for 30 years, Kirk outfitted many of the cowboys and ranchers of Eddy County. He was known to spin many yarns to the men who would gather in his shop.

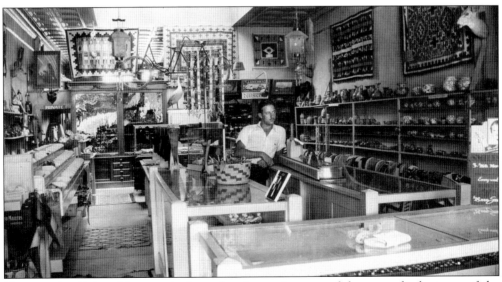

Photographer Robert Nymeyer is shown leaning against one of the many display cases of the Navajo Curio Store, which held Native American treasures and jewelry. The stuffed swans in the background were a familiar feature in many of the shops of Carlsbad, as they seemed to migrate around the town.

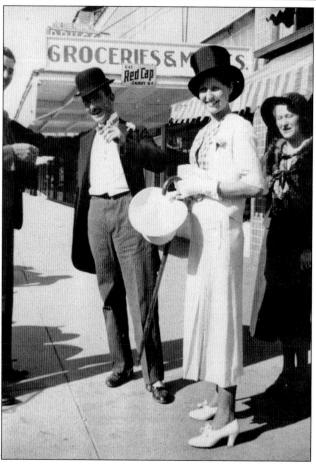

Travelers gather at the base of the concrete architectural marvel, "the Flume," on their early Harley-Davidson motorcycles. C. H. Lang in Chicago, Illinois, opened the first Harley-Davidson dealership in 1904, selling one of the only three motorcycle models available. Harley obtained the nickname "Hog," because the racing team would take the company mascot, a pig, on its victory lap.

J. R. Joyce, one of the most widely know Eddy County characters, began the tradition of an Easter Parade for Carlsbad in 1932. Even though it only lasted a couple of years, and the four people pictured were the only ones to participate, it caused quite a stir. Shown from left to right are J. D. Merchant; J. R. Joyce; his longtime companion, Roxie McMahan; and Dorothy Flowers.

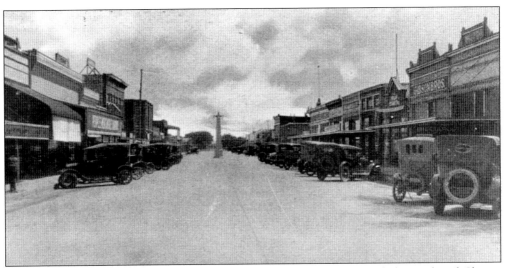

Before 1926, the streets in Eddy County were dirt, leaving its residents with dust and mud. Shown is Carlsbad's first paving project on Canyon Street in the main business district. Canyon Street soon became the hub of the town of Carlsbad.

The decorated car was the precursor to the parade float. This car was decorated for the town's first Armistice Day parade on November 11, 1919. Also known as Remembrance Day, Armistice Day is now celebrated as Veterans Day.

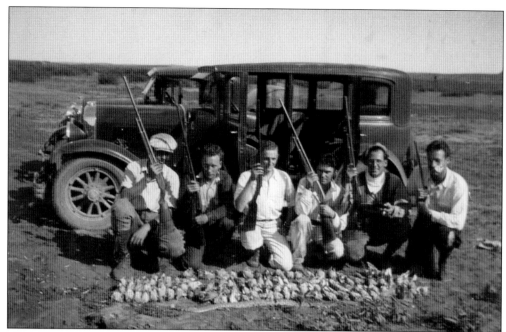

Here is a group of Eddy County hunters with their afternoon quarry of dove and rattlesnakes. Shown from right to left with their bounty are Bob Nymeyer, Dave Wilson, Ted Fullerton, Tommie Futon, Glenn Hamblen, and Jay Pond. Nymeyer has a bandage on his cheek, which he used while recovering from a black widow spider bite.

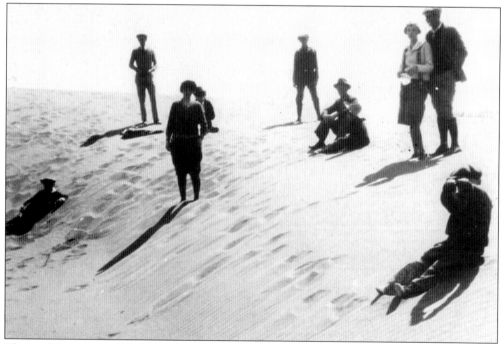

The sand dunes east of Carlsbad, close to Loco Hills, provided a playground for area residents and were likened to the White Sands of the Pecos Valley. These dunes still provide the area's off-road enthusiasts a challenging afternoon of fun.

A hunting party is pictured on their way to McKittrick Canyon. The known persons shown in this 1920 image of the party are, from the left, F. G. Herbert, F. A. Wallace, Troy Wallace, and W. G. Donnelly. McKittrick Canyon has always been a favored spot for locals to visit.

Here is the interior of the Eddy County Abstract Office, owned by founding fathers C. H. McLanthan and Francis G. Tracy. McLanthan was instrumental in forming the Democratic Party in Republican-dominated Eddy County and was in the real estate business.

Eventually providing Carlsbad and Artesia with jobs, Meyer's Printing was a bustling, intense place in which to work. Staff members are pictured collating a newspaper published by International Minerals and Chemical Corporation, a local potash mine that is now known as Mosaic.

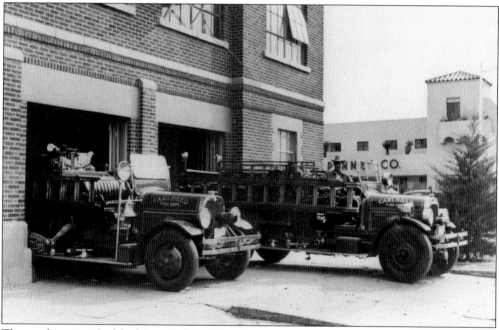

The combination Carlsbad City Hall and Fire Department was located at the northeast corner of Fox and Canal Streets, diagonally from the First National Bank Building. Carlsbad has a diverse architectural style, with this city hall a traditional brick design and the JC Penney's building, located across the street, done in a Spanish style.

Daredevil Frank Kindel is pictured riding across the Flume with "no hands" on a motorcycle for the Warner News Organization, while Kenny Davis looks on in this 1916 image. The width of the top rail of the Flume is no more than 12 inches across, making this maneuver highly risky.

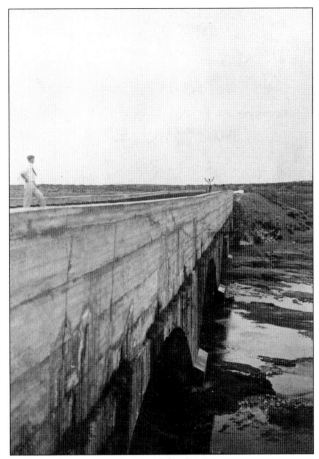

Vying for the title of Miss Carlsbad in 1949, contestants were, from left to right, Ruth Morgan, Barbara Alexander, Mary White, Juanita Burchalter, Louise Hanric, Shirley Swan, Pat Fender, and Bonnie Burgett. These pageants have since been discontinued.

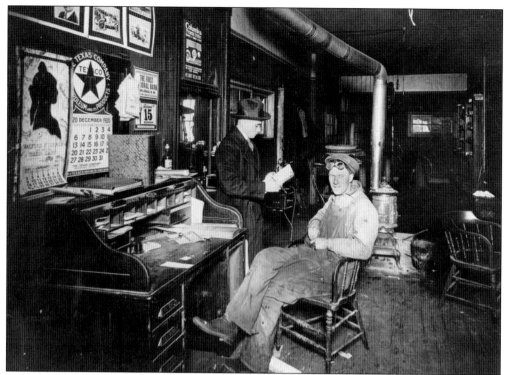

The interior of the Texas Company, located at 810 North Main Street, shows an employee seated at the roll-top desk. This was a dry goods store that provided Texaco products to Eddy County, stating in the city directory ad, "There is a Texaco lubricant for every purpose."

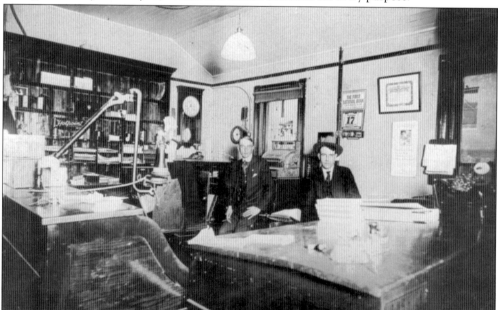

The Public Utilities Company Office, located at 105 South Canyon Street in Carlsbad, was managed by Eugene (Gene) Roberts, shown in the middle of the photograph. The company's predecessor had the telephone numbers 114 or 115 in 1939.

The Carlsbad train depot telegraphs office shows Stan Blocker, back right, as a young man. Stan's family published the local newspaper, the *Eddy Argus*, housed in the southeast office of the First National Bank Building on the corner of Canal and Fox Streets. The Blockers would eventually move to Artesia to become part owners of the *Advocate* there.

Leaders of the Pennebacker-Joyce Mercantile of Eddy (soon to be Carlsbad) borrowed the top hats they are wearing off the shelves for the dapper shot. The two owners, Ed Pennebacker and John R. Joyce, are seated in front in this 1891 Stringfellow photograph.

The Stockwell family is pictured in their delivery truck with Carlsbad's Camp Fire Girls. This group is headed off for a camping trip in McKittrick Canyon. The Stockwell family owned the first drive-in service station in southeastern New Mexico.

In 1959, Ira Stockwell, Carlsbad's fire chief, gives a dog treat to Smokey, the firehouse mascot, as Sparky looks on. Stockwell would make handmade wooden gavels in his leisure time, which were highly prized by all who were presented with one. Stockwell served on the Carlsbad City Council for six years and was honored as Carlsbad's leading citizen.

The Knowles, New Mexico, Tennis Club members include, from left to right, William Woerner, Mabel Heard, Charlie Miller, Lillie Thomas, Ilene Bourland, and John Emerson. They are gathered for a tennis match on April 9, 1910. Knowles was a part of Eddy County for a short time, before being welcomed into Lea County.

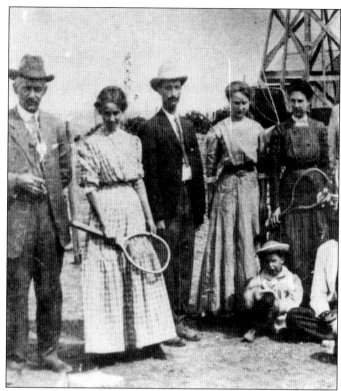

Annie Morrison flanks owner Richard Morrison, located on the left, as their employee, Al Boeglin, looks at inventory in Morrison Furniture Store. Boeglin would go on to own the Albert Boeglin Furniture Company at 203 South Canal Street.

This barbershop scene from 1922 shows Willard Keen, barber Claude Farris, Mr. Grogan, and Bill Bartlett as they undergo the rituals of a haircut and shave, as owner Clayton Miller looks on. Miller's Barber Shop was located at 124 South Canyon Street in Carlsbad.

Here is a St. Valentine's banquet for the parents of the local kindergarten students. Isabelle Drury, the wife of the town chiropractor, set up decorations. Drury, a dedicated teacher, was known for her elaborate parties and celebration. She used a Baptist church hall for her classes.

Aviatrix Amelia Earhart stands in the lower cave at the Carlsbad Caverns on September 11, 1928, as she made the most of a delay in Hobbs while on route to the first round-trip transcontinental U.S. flight done by a woman. Earhart ran into trouble over Fort Worth, Texas, when a strong wind swiped an aerial chart pinned to her skirt. Lost and out of fuel, Amelia landed in the middle of Hobbs, New Mexico, on East Broadway and rolled to a gas station where she got her silver Avian serviced.

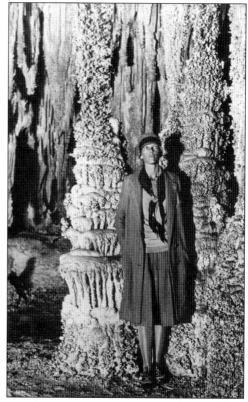

A Catholic Mass was held underground and was given by a bishop of the El Paso Diocese on Easter Sunday, April 24, 1949. The Carlsbad Caverns would host Easter services at the Rock of Ages formation in the cave, which included turning out all the lights to give the attendees the feel of what it was like to be an early explorer.

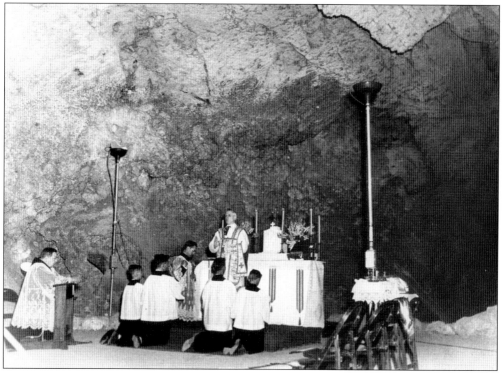

The Carlsbad Fire Department is shown testing the Seagraves Pumper on Canal and Mermod Streets. Standing left to right are fire chief Ira Stockwell, Henry Samples, George Thomas, Mr. Boone from the Seagraves Company, and Nathan Wright. This would be the fire department's first pumper, acquired in 1928.

Col. Tom Boles of the Carlsbad Caverns supervises the work being done on one of the work trucks. Early roads around the Carlsbad Caverns were not paved and could be treacherous. With the nearest town being 30 miles away, the work had to be done on site.

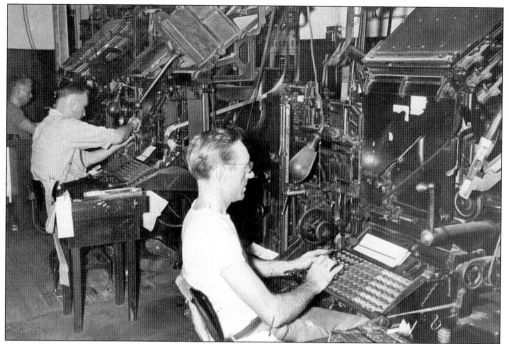

The pressroom of the *Carlsbad Current Argus* in 1948 bustled with activity as the pressmen worked on the latest issue. The early newspaper, the *Eddy Argus*, was published in the southeastern corner of first-story store of the First National Bank Building in 1898.

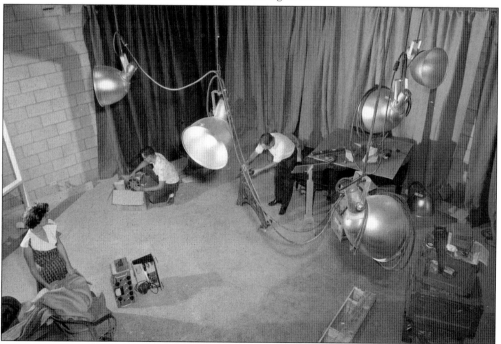

Pictured is the interior of the KAVE-TV station in 1952. The station broadcasted from a location on top of "C-Hill," above Carlsbad, and brought local and regional news and other programs to the citizens of Eddy County.

The amusement rides at the Carlsbad Municipal Beach, which included a Ferris wheel, Merry-go-Round, train, swinging chairs, Tilt-a-Whirl, and kiddie rides, were a delight to all who enjoyed the park. The large tract of land along the Pecos River was donated by wealthy heiress Caesarine Graves, a tubercular patient who came for the climate and fell in love with the land. The land was given with the condition it was never to be used commercially and had to be used for the people.

High-stepping majorettes Betty Grant, Edna Ball, Mary Goff, Jackie Hunt, and Betty Hall show off their leadership skills in the Carlsbad High School stadium, located on the corner of Church and Mesquite Streets. This was the same stadium where rodeos were held during the summer months.

The 1931 Carlsbad football team was the first to call themselves the "Cavemen." A healthy rivalry was generated between Carlsbad and the second largest town in Eddy County, the Artesia Bulldogs. The "Battle on the Pecos" remains the highlight of the football season.

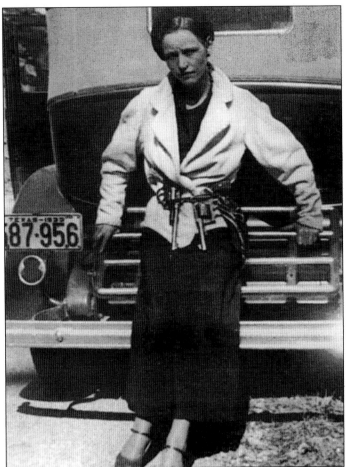

Bonnie Parker's aunt, Nellie Stamp, lived in Carlsbad, and it was during a visit to her that Bonnie and her partner in crime, Clyde Barrow, kidnapped Sheriff Deputy Joe Johns and took him to Texas. They eventually released him near San Antonio, Texas. Johns was heard to say he was extremely lucky, since Bonnie was calling for his death.

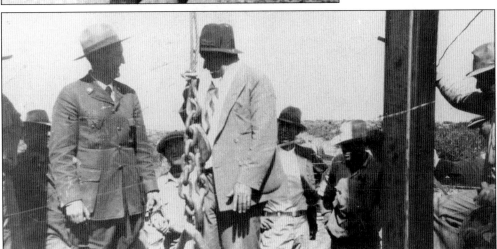

Col. Tom Boles, the superintendent of the Carlsbad Caverns, discusses the descent into the cave with famed humorist Will Rogers. Rogers appears to be apprehensive in the method but was still willing to follow through with the visit on May 10, 1931. The two rode the bucket down the new elevator shaft.

Clay McGonagill, a champion roper, is shown in this photograph. It is said his best time was 17 seconds. He was elected into the Cowboy Hall of Fame in 1975, some 54 years after his death. The McGonagill family is among the first pioneer families of Eddy County.

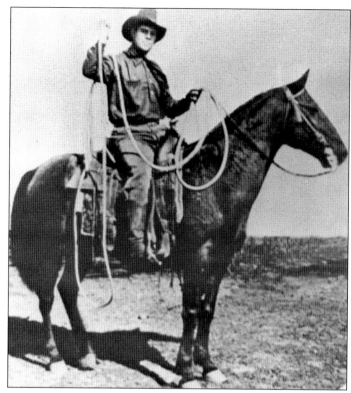

Jessie Huff, shown in the white dress, sitting on the front step, ran the Hilltop Nursery School, which was located at 2509 San Jose Boulevard in 1949. The school catered to the children of the San Jose subdivision of Carlsbad.

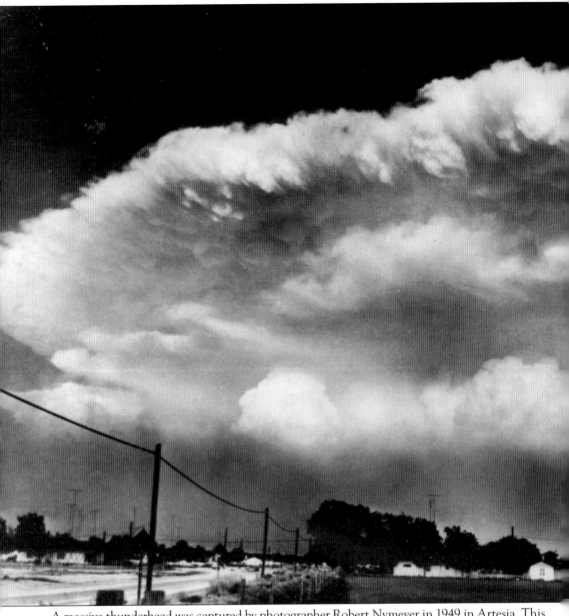

A massive thunderhead was captured by photographer Robert Nymeyer in 1949 in Artesia. This illustrates the typical cumulous clouds that gather in summer afternoons, producing lightning, thunder, and sometimes rain. Truly one of the most wonderful scenes on a summer evening is the development of a thunderhead. Robert Nymeyer was a well-known local photographer, who

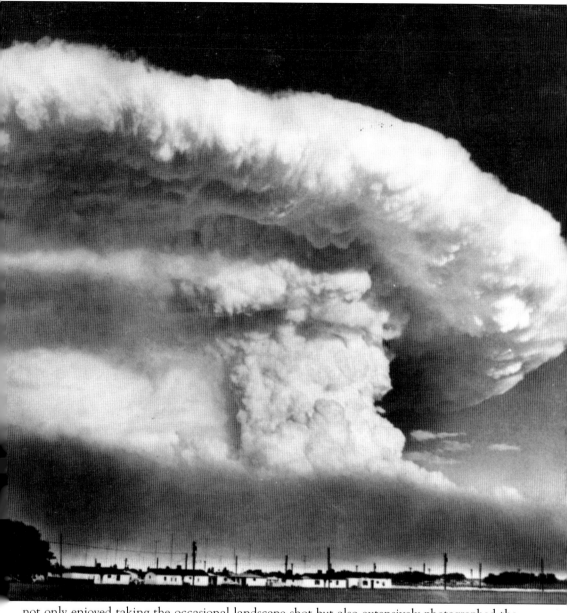

not only enjoyed taking the occasional landscape shot but also extensively photographed the Carlsbad Caverns National Park for his books, *Carlsbad, Caves and a Camera*, and *Carlsbad Cavern: The Early Years*.

Postmaster William H. Laidlaw is shown standing outside the Loving Post Office in this October 17, 1912, image. Originally named Vaud by the Swiss immigrants who settled the area, Loving was eventually renamed to honor cattleman Oliver Loving, who was mortally wounded at that location.

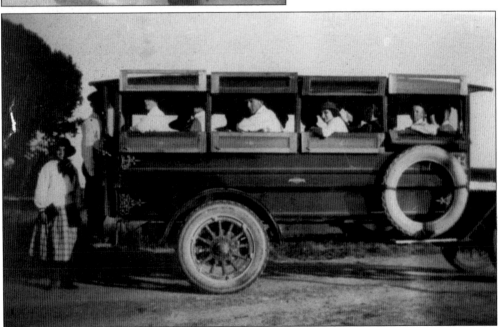

The school bus that ran between Loving and Carlsbad, New Mexico, is shown in this 1920 shot. The sides and roof were made of wood and painted a dull black. An iron crank, which hung from the radiator, would start the engine. A tire repair kit was under the driver's seat in case of flat tires, which happened frequently.

Famed Carlsbad Caverns photographer
Ray V. Davis and his first wife, Myrtle,
take a spin in his newly acquired
1921 motorcycle that has a stylish
sidecar. The motorcycle appears to be
a Harley-Davidson, which introduced
its JS Sidecar Twin in 1919.

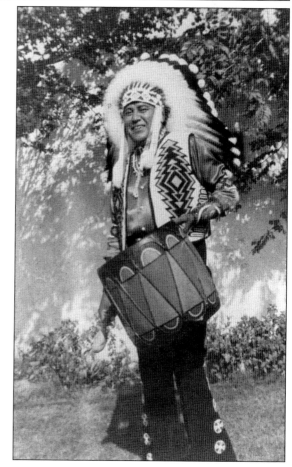

Chief Sunny Skies, otherwise known
as Clyde Hunt, was a local legend
as a jewelry maker and shop owner.
Sunny Skies would perform traditional
dances in full regalia much to the
delight of tourists who frequented
his shop, the War-Bonnet Indian
Village, at 720 South Canal Street.

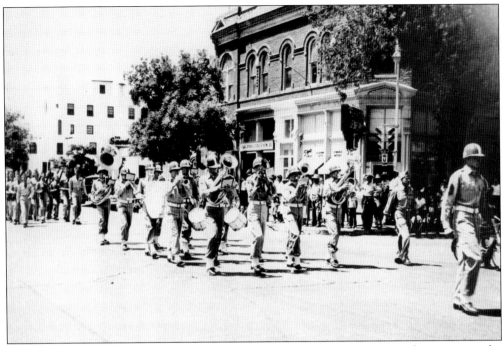

The 1952 Fourth of July parade, featuring members of the Eddy County military, passes the First National Bank Building and La Caverna Hotel as it travels north on Canal Street. Parades continue to be a source of enjoyment for the citizens of the county.

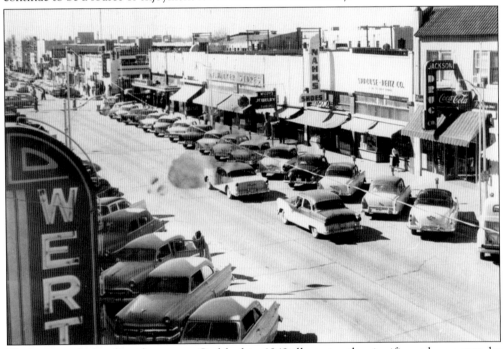

This image of a bustling downtown Carlsbad in 1949 illustrates the significant boom seen by Eddy County after the end of World War II. Returning soldiers established homes and secured employment to boost the local economies of the county.

BIBLIOGRAPHY

Cox, Jerry R., PhD. *Ghosts of the Guadalupes: A Factual History of Agriculture, Families, and Violence between 1905 and 1955 in Southern New Mexico.* Carlsbad, NM: J5 Consulting, 2005.

Eddy County, New Mexico to 1981. Carlsbad, NM: Southeastern New Mexico Historical Society, 1982.

Eddy County . . . A Fond Look Back. Carlsbad, NM: Valley Savings and Loan, 1980.

Julyan, Robert. *The Place Names of New Mexico.* Albuquerque, NM: University of New Mexico Press, 1996.

LeMay, John. *Chaves County.* Charleston, SC: Arcadia Publishing, 2009.

Lewis, Charles William. *Early Settlers in Carlsbad, New Mexico, and Vicinity.* Carlsbad, NM. 1976.

Nymeyer, Robert. *Carlsbad, Caves and a Camera.* Teaneck, NJ: Zephyrus Press, 1978.

Patterson, Patricia. *Queen, New Mexico: A Historical Perspective on the Settlement in the Guadalupe Mountains, 1865–1975.* Roswell, NM. 1975.

Waltrip, Lela and Rufus. *Artesia: Heart of the Pecos.* Canyon, TX: Staked Plains Press, 1979.

www.arcadiapublishing.com

MAP SEARCH

Discover books about the town where you grew up, the cities where your friends and families live, the town where your parents met, or even that retirement spot you've been dreaming about. Our Web site provides history lovers with exclusive deals, advanced notification about new titles, e-mail alerts of author events, and much more.

Find Your Place in History.